IMAGES
of America

THEATRES OF
OAKLAND

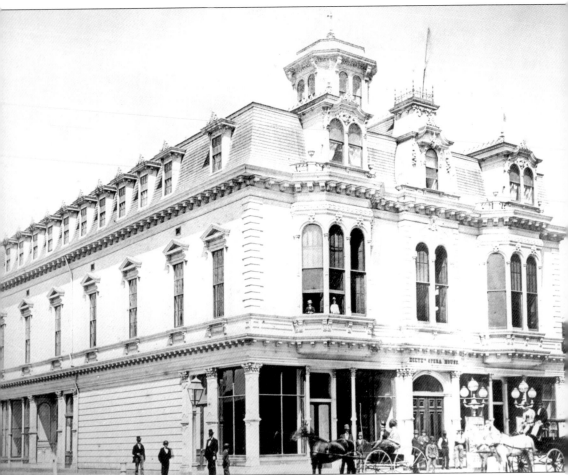

Oakland's theatre history began in 1873 when the University of California decamped to Berkeley, leaving this large hall at its downtown campus to become Oakland's first theatre of consequence. Renamed Dietz Opera House, the building stood at the northeast corner of Webster and Central (Twelfth) Streets and for several years was Oakland's only theatre. Despite the apparent size of the building, the theatre on the second floor could accommodate a "crush" of only several hundred. The audience sat on individual chairs on a level floor that was also used for dances. Without a resident stock company, the Dietz relied on one-night touring attractions and so was dark on many nights. Among the businesses downstairs were a saloon and wholesale plumber. Ironically the Dietz burned to the ground in 1911 during the height of the controversy over fire safety in the rapidly proliferating motion-picture theatres.

ON THE COVER: Still riding the crest of the attendance wave following World War II in September 1947, the Fox Oakland at 1819 Telegraph Avenue offers Bing Crosby and Barry Fitzgerald, earlier paired in the popular *Going My Way*, in another musical excursion, *Welcome Stranger*. The cofeature, *Hit Parade of 1947*, is Republic's fourth takeoff on the wildly successful radio show, *Your Hit Parade*, which aired on Saturday nights. The outer lobby has been "Skouras-ized," a form of styling named after theatre executives Charles and Spyros Skouras, who added modern design elements to older theatres. Here stainless steel was used to line the exterior lobby and to create a cloud ceiling and a jukebox-style box office. The Fox closed "temporarily" in 1965. It reopened and closed sporadically over the next eight years, and the results, good or bad, depended on the attraction.

IMAGES
of America

THEATRES OF OAKLAND

Jack Tillmany
Jennifer Dowling

ARCADIA
PUBLISHING

Published by Arcadia Publishing
Charleston SC, Chicago IL, Portsmouth NH, San Francisco CA

Printed in the United States of America

Library of Congress Catalog Card Number: 2006928748

For all general information contact Arcadia Publishing at:
Telephone 843-853-2070
Fax 843-853-0044
E-mail sales@arcadiapublishing.com
For customer service and orders:
Toll-Free 1-888-313-2665

Visit us on the Internet at www.arcadiapublishing.com

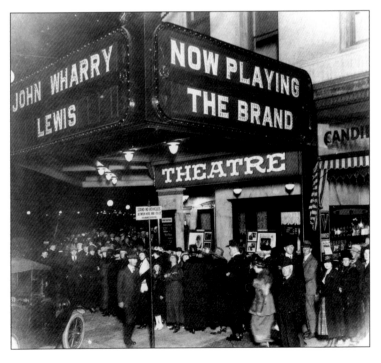

In 1919, crowds stand patiently in line to hear John Wharry Lewis and his "orchestra with a soul" at the American Theatre, located at 1709 San Pablo Avenue at Clay Street. In an era when pre-electric acoustical recordings were all that was available, regular radio programming had not yet arrived, and, of course, television did not exist, live musical entertainment was king, and Lewis was deemed an attraction equal to the films shown.

CONTENTS

ACKNOWLEDGMENTS

Except as noted, all pictures in this book are from the personal collections of the authors. We are grateful to all the photographers and collectors who documented and preserved Oakland history, especially Tom Gray and the late Vernon J. Sappers. Thanks also to Gail Lombardi and Betty Marvin at the Oakland Cultural Heritage Survey for providing insights and access to city records.

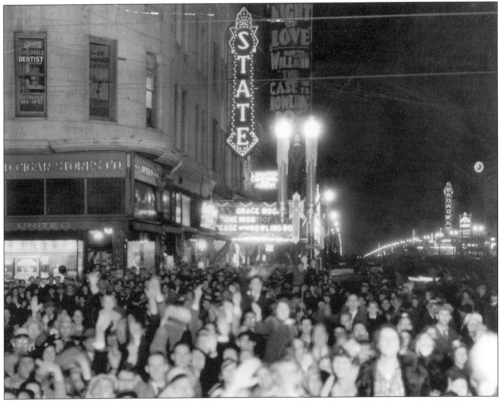

The neon clock over the Broadway Theatre at 1320 Broadway (at right) shows it's 11:45 p.m. as the downtown crowd gathers in front of the State Theatre to say farewell to 1934 and to greet the New Year; it was a tradition memorialized each January 1 on the front page of the *Oakland Tribune*. Streetlights decorated to look like burning candles lend a festive air. Broadway at Fourteenth Street was the place to be for celebrations. This was the midst of the Great Depression, but the crowd was happy and the street scene was vibrant. It was an era when downtown was a destination, not just on New Year's Eve, but 365 days a year, and theatres played a major role in the life of the city.

INTRODUCTION

From stage plays to vaudeville to motion pictures, Oakland offered great entertainment and plenty of it. The focus on live performances in the downtown theatres at the beginning of the 20th century gave way to motion pictures in the 1910s. Oakland's first motion picture was screened in 1901, and within a few years, every venue was offering some sort of film, including the vaudeville houses that used films to help bring in audiences. The early films were actualities, such as prize fights, bustling downtown crowds, or travel to an exotic land, then short stories and serials were introduced, and eventually the feature-length film became the norm.

In the 1910s, little operations, often called photoplay theatres or nickelodeons, sprouted up in converted stores downtown and along streetcar lines. Despite the popularity of the little theatres, controversy raged concerning their safety and their alleged unwholesome offerings. An *Oakland Tribune* editorial called them "dirty and dangerous." Nevertheless the motion-picture houses continued to steal audiences from the bigger, more expensive live venues. In 1911 and 1912, authorities in Oakland tried to ban stages in movie houses and to prevent mechanically operated projectors, but the restrictive ordinances did not halt the explosive growth. The single biggest year for Oakland theatre building was 1912. Turnover, change, and business consolidation characterized the early years, with a new name usually signaling a change of ownership or a theatre remodel. Among those serving Oakland's early movie-going public were the Bijou Dream, Fisher's, Marlowe, Empire, and Novelty theatres. Within a short time, the theatre business evolved into a major industry.

Another theatre building boom occurred in the mid-1920s, just before sound pictures were introduced. In that golden era, the business was dominated by chains, many of which had their origins as vaudeville circuits. In Oakland, the major entertainment companies were Golden State Theatres, Blumenfeld, Fox West Coast, Orpheum, Turner & Dahnken, Beach & Krahn Amusement, and Pantages. Although Golden State Theatres operated the largest number of theatres in Oakland, it was never a "downtown" enterprise, preferring to cater to the city neighborhoods and to small towns. The most lavish and largest theatres in Oakland were built by Fox West Coast. They debuted in the 1920s and 1930s with glamorous openings featuring Hollywood stars, speeches, and parades. Oakland's two largest theatres, the Fox Oakland and Paramount, seating more than 3,000 each, were larger than any on the West Coast, except for San Francisco's fabled Fox, which seated 4,500.

After the incredibly prosperous decade of the 1940s, stimulated by the World War II patronage boom, the introduction of television in 1949, as well as other factors, caused business to decline, and by the mid-1950s Oakland's theatres struggled to find an audience. The big venues and many neighborhood sites closed and were adapted to new uses such as apartments, churches, stores, bowling alleys, and skating rinks. Among the survivors are the Grand Lake, Paramount, and the Fox Oakland theatres (the latter now shuttered). The Paramount Theatre of the Arts, a splendid 1930s art-deco masterpiece offering both live performances and films, is currently Oakland's only single-screen venue.

Innovations to come were newsreel theatres, drive-ins, wide-screen projection, and multiplexes. Open all night with continuous shows, the newsreel theatre was a popular downtown attraction during the war years of the 1940s, but interest waned in the newsreel concept with the introduction of television news in the 1950s. In order to hold on to audiences drawn to the increasing amount of television programming, many theatres distinguished themselves by offering foreign films and adult fare. The lack of parking that led to the decline of many downtown theatres was not a problem at motor movie or drive-in theatres. Three Oakland shopping centers, with their ample parking lots, also added movie theatres, which, with one exception, were all designed

as multiplexes. Older single-screen theatres also converted to multiplexes in order to increase attendance. The last movie theatre constructed in Oakland, Jack London Cinema, opened as a six-plex on December 15, 1995, and has since expanded to nine theatres, providing state-of-the-art projection, stereophonic sound, and stadium seating in order to meet the demands of today's movie audiences.

This historical tour is arranged geographically beginning with downtown and West Oakland, with a separate chapter on three 1920s movie palaces. From there, it proceeds to the neighborhoods to the north and east before returning to downtown in the last chapter to visit Oakland's crown jewel, the Paramount. Where a theatre address is given, it follows Oakland's post-1912 address numbering system and its historical street name. Enjoy the show!

SEATING CAPACITY IN THE YEAR 1949 FOR OAKLAND, CALIFORNIA THEATRES
By 1949, Oakland's seating capacity was at a peak: 43,330 seats (not including the closed State) in a city with a population of 302,163, or about one seat for every seven people. However big changes were on the horizon. Television broadcasting began in the Bay Area with KPIX, channel 5, in December 1948; KRON, channel 4, and KGO, channel 7, would go on the air seven months later in July 1949. Little did anyone realize that this development, as well as other changes in the cultural environment, would mean that most of the theatres on this list would eventually become just a memory.

Theatre	Capacity	Theatre	Capacity	Theatre	Capacity
Broadway	821	Gateway	1,159	Piedmont	824
Capitol	952	Granada	1,495	Pix	667
Central	1,548	Grand Lake	2,177	Rex	550
Chimes	1,276	Hopkins	892	Rialto	740
Dimond	1,325	Laurel	1,012	Roxie	1,075
Eastmont	837	Lincoln	880	Senator	1,624
El Rey	700	Moulin Rouge	376	Star	635
Esquire	1,471	New Peralta	450	State (closed)	1,459
Fairfax	1,493	Newsreel	286	T&D	2,632
Foothill	687	Orpheum	2,561	Telenews	571
Fox	3,335	Palace	1,146	Tower	600
Franklin	813	Paramount	3,434		
Fruitvale	1,224	Parkway	1,062		

One

THE CURTAIN
RISES DOWNTOWN

The Dewey Theatre, located at 320 Twelfth Street between Webster and Harrison Streets, only half a block from the Dietz Opera House, was a popular venue in the late 19th century for stage acts and vaudeville. The Dewey also occasionally showed movies and "illustrated" songs where illustrated lyrics were projected onto the screen. The Dewey closed in 1906, just as motion pictures were getting a foothold. Over the next 30 years, the center of downtown entertainment shifted from the lower end of Broadway north toward Grand Avenue. This chapter covers that entire area with the exception of the Paramount, Fox Oakland, Grand Lake, and Orpheum theatres, which are highlighted in separate chapters. Also included in this first chapter are the theatres in West Oakland, a district whose principal east-west thoroughfare, Seventh Street, stretches from downtown west to Oakland Point. Readers should note that at many sites, theatre names came and went with rapidity, as was the case with the Pantages, known also as the Lurie, Hippodrome (one of two in Oakland), the Premier, Roosevelt, and Downtown.

In 1901, Oakland's first moving-picture theatre debuted at the northeast corner of Broadway and Thirteenth Street. Peck's Broadway was operated by Albert E. Peck, an experienced showman, and his wife, a "high-grade" vaudeville performer. They offered "a refined, cozy little place of amusement that ladies and children can attend day or evening without escort." In 1903, Peck's (or Pex) relocated to San Pablo Avenue, and this location only offered kinetoscope exhibition. During the 1970s urban renewal, the buildings pictured here were razed. (Courtesy Oakland History Room.)

The Empire Theatre at 466 Twelfth Street was one of the few places in the East Bay where life was lost during the April 1906 earthquake when a wall collapsed on people sleeping next door. Here is a happier occasion in 1905 when a caged performer, billed as a wild man, rolled in to publicize his appearance at the Empire. During its short run (1904–1906), the theatre was called both Empire and Lyric, two names later used at other Oakland theatres.

Citizens offered $10,000 to persuade Joseph Macdonough to build a first-class theatre in Oakland. In 1892, he commissioned architects Cuthbertson and Mooser, later active in the post-1906 rebuilding of San Francisco, to design a theatre on the southeast corner of Fourteenth Street and Broadway. After a slow start, the Macdonough Theatre prospered, reflecting the social growth of Oakland. This photograph was translated by Britton and Rey Lithographers into a best-selling postcard. In 1956, the East Bay's first glass-curtain skyscraper replaced the old theatre.

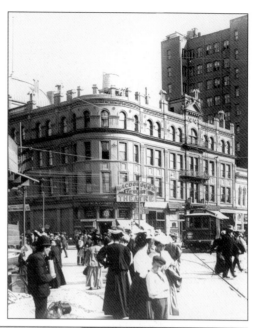

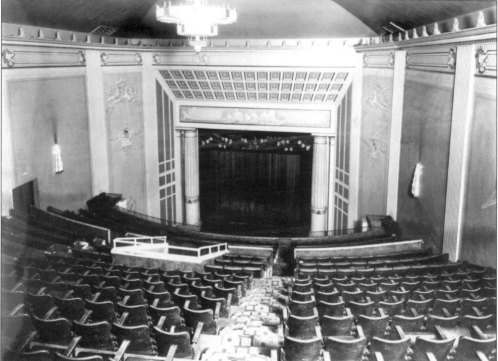

The Macdonough changed its name to State, a popular theatre name, and eventually dropped plays and vaudeville in favor of motion pictures. This interior view, taken in 1945, shows what remained from a 1923 remodel (one of several over the years) when it was Loew's State. Exterior changes included moving the entrance from Fourteenth Street to 1320 Broadway and adding an electric roof sign. The theatre closed months after this photograph was taken due to problems meeting modern-day fire regulations.

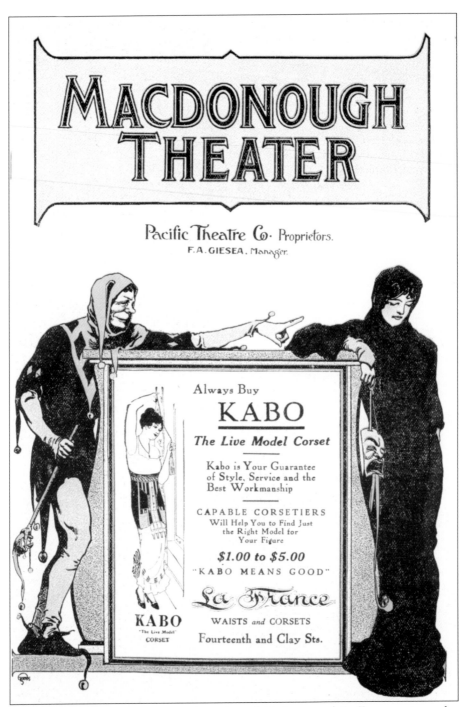

The 1914 Macdonough program was an advertising vehicle for not only La France waists and corsets as pictured on its cover but for now-forgotten products such as Zam-Zam candy laxative, Keaton non-skid tires, Giersberger wines, and Clark-Gandion Trusses. Stage drama was the Macdonough forte, but it joined in on the movie craze to present short films or "actualities" of train wrecks, horse races, automobile collisions, and fox hunts. Admission prices ranged from 50¢ to $2.

12

Talking pictures arrive! Al Jolson, in *The Jazz Singer*, took New York City by storm in October 1927 and arrived in Oakland five months later in March 1928. Three months later, the State would be renamed the Vitaphone and remain so for two years, as Warner Brothers' stream of Vitaphone features made the Oakland public talkie conscious. Thousands of vaudeville entertainers immortalized themselves on Vitaphone celluloid but, at the same time, hastened the ends of their careers as live performers.

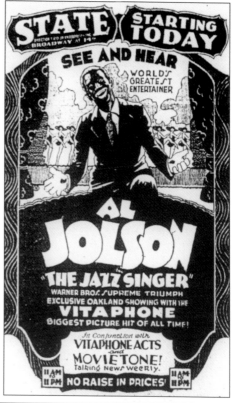

When *Arsenic and Old Lace* was released in 1944, Oakland was supporting the war effort 24 hours a day in three shifts. War-industry workers and military personnel packed the downtown shows day and night. Service personnel in uniform got discounted admission to most theatres that competed with arcades, dance halls, and bowling alleys for the military dollar. Day or night, downtown was the place to be.

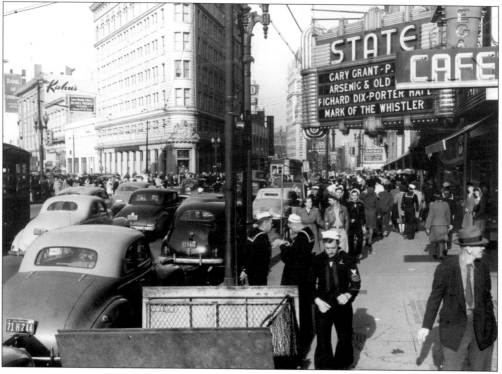

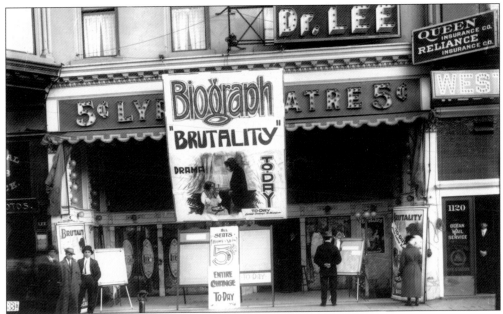

In September 1902, Oakland's second motion-picture theatre, the Novelty, opened at 1122 Broadway, seen here *c.* 1912 after a name change to Lyric. Its original proprietor, Tony Lubelski offered "gilt edge" vaudeville, as well as motion pictures, in an auditorium that seated 1,200 in "easy orchestra" chairs. *Brutality* was a 1912 D. W. Griffith two-reeler running approximately 25 to 30 minutes, depending on the speed at which it was projected. Connected to the theatre was a 7,500-square-foot penny arcade.

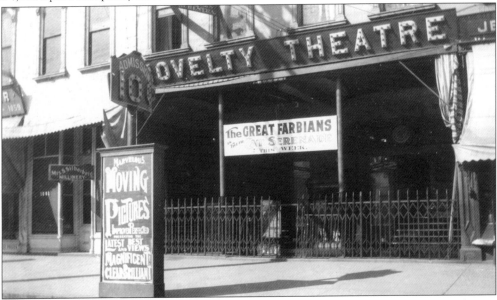

The Novelty name moved across the street to 1121 Broadway to a site that would support a theatre until 1972. This photograph is dated about 1908; the next year the theatre became the Broadway. Like many of the early downtown theatres, this one was built in an existing commercial building. Tucked behind the modest entrance was a 56-foot-wide stage with a three-story stage house for live acts that accompanied the moving pictures.

14

Although the smaller Camera Theatre, next door to the Broadway, was managed by the same company, the Camera admission was 5¢ less where the offering was "artist deserts wife for arms of Parisian vampire." Apparently live vaudeville at the Broadway warranted the extra nickel. Miss C. Hetherington was the Camera's photoplayist. This position, often filled by women, was available in abundance due to the popularity of piano lessons. Marie White was cashier for the Camera.

For about a year, the Broadway was known as the Republic. Note that the "Vaudeville & Pictures" sign at left is flattened against the building; it swung out over the street when the theatre was open, then back against the building when it was closed and/or winds made it hazardous to pedestrians. *The Serpent* starred Theda Bara as a female vampire. In the years before World War I, the actress gave a whole new meaning to the word "vamp."

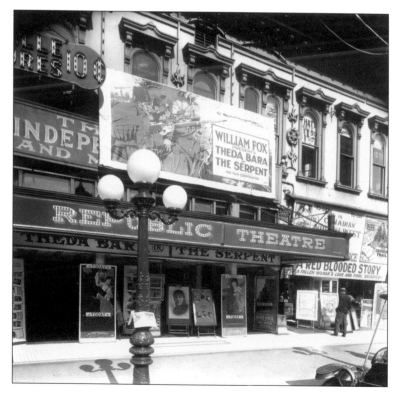

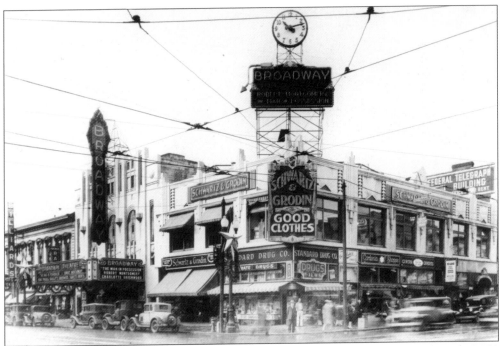

The Broadway reinvented itself and survived. It is pictured here in 1932, two years after a $45,000 "remodel" by San Francisco architect Frederic F. Amandes. Its exterior changed little over the next 40 years, the signature vertical a familiar landmark at Twelfth Street and Broadway until 1972, when the theatre was razed. The clock is the same one that is visible in the New Year's Eve photograph of the State (seen on page 6) in which the Broadway appears in the background.

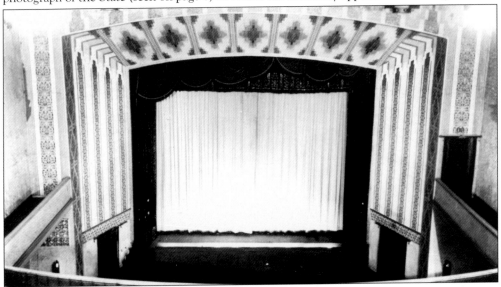

This 1942 view shows the art deco–influenced interior of the rebuilt 821-seat Broadway, a redecoration of an older structure almost solely in paint. In 1932, dated cast ornament had been stripped off, everything was given a smooth coat of plaster, and the painters did their work stenciling bold geometric designs. Note the two promenades: the one on the right leads to a fire escape, but the one on the left leads nowhere just for symmetry.

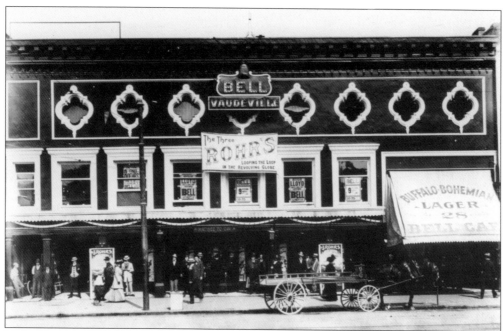

The Bell Theatre at 1436 San Pablo Avenue, designed in 1903 by architect Walter J. Mathews, featured vaudeville at "popular prices," moving pictures, and an arcade with peek-style picture machines, song boxes, weighing machines, and fortune-telling devices. Mathews also did the Twelfth Street Orpheum and is said to have built the equivalent of four miles of buildings. In 1912, during construction of the current city hall, the Bell was converted to new uses, and in 1995, the building was demolished.

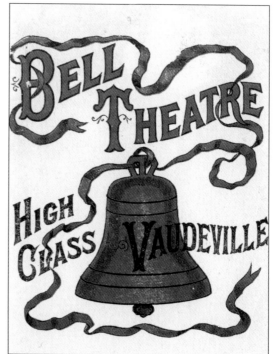

The program at the Bell for the week of September 30, 1907, opened and closed with a march played by the six-member house orchestra. The music signaled a break in the performance so the audience would know the next show was about to begin. Acts included comedy sketches, a monologue, a movie, music, and a wooden-shoe dance. A solo and "illustrated" songs by America's highest-paid "picture singer," the boy tenor Master Harold Hoff, rounded out the program.

Broadway's second big theatre was Ye Liberty Playhouse at 1424 Broadway. The twin-arched entrances to the Syndicate Realty Building led to offices (left) and to the playhouse (right). William Woollett, later responsible for Grauman's Metropolitan and co-architect for the Million Dollar Theatre in Los Angeles and a specialist in creative use of concrete, was architect for Ye Liberty. Built in 1903, the year of the Iroquois Theatre fire in Chicago, concrete construction lent some measure of fireproofing to the theatre.

Advertising in theatres is nothing new, as demonstrated by this May 1917 view of the drop curtain at Ye Liberty Playhouse. These advertisements were aimed at the well-heeled crowd. (Courtesy Oakland History Room.)

The little sign above the steps that says, "The Fight," is the only advertising in this mid-1910s view of Ye Liberty. Above the entrance are masks of tragedy and comedy, the incised name of the theatre, and its date of construction; ornamentations that were lost when these steps were replaced by retail storefronts. Inside was the auditorium with a 75-foot-diameter revolving stage conceived by Harry W. Bishop, who would later develop a similar stage at the Bishop Playhouse.

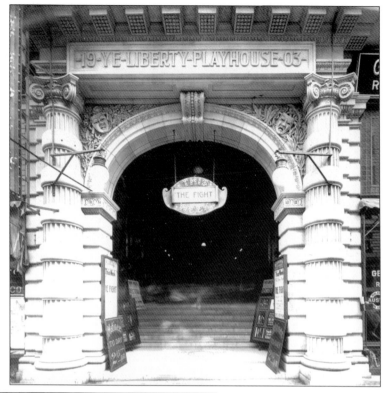

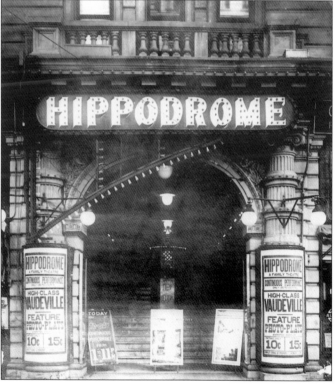

For a short period of time around 1917, Ye Liberty operated as the Hippodrome, "A Family Theatre" offering 10 daily hours of continuous "High-Class Vaudeville, Feature Photo-Plays, and Animated Weeklys" and "Any Seat 15¢, Matinees 10¢." Even in 1917 dollars, that sounds a little too good to be true, and the fact that its Hippodrome period was so short-lived is pretty good evidence to that fact that even for those low prices, patrons could do better elsewhere.

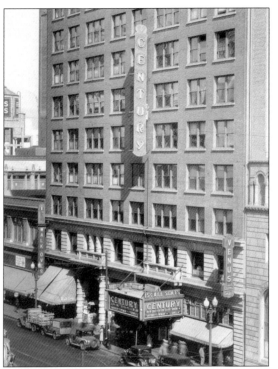

By 1930, Ye Liberty had been renamed the Century, vaudeville was dead, talking motion pictures were here to stay, and the 1929 stock market crash was having its impact on the nation's economy. For 15¢, patrons could see two all-talking features plus short subjects with three complete changes of program every week. In 1961, the theatre at the rear, then called the Central (its fifth name), was torn down and replaced by a 100-car parking lot. The Syndicate Building itself remains.

Happy days are here again! It was easy to make a buck on Broadway in the halcyon days of World War II, and the 1,548-seat Central was no exception. Even forgettable films like *Child Bride* and *Mountain Rhythm* kept the wickets turning. The See's candy store next door, where audiences stopped for treats, was not complaining either.

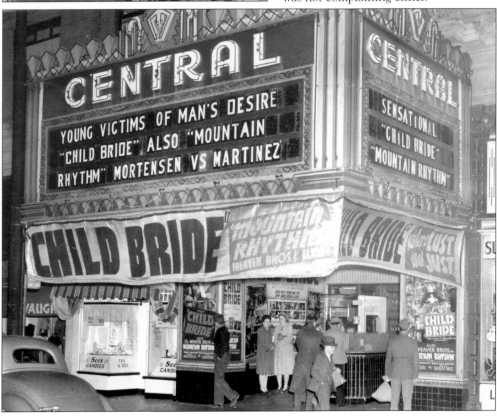

In 1911, the *Oakland Tribune* claimed that the newly opened Oakland Photo Theatre at 1532 Broadway was the largest of its type in the country. The $21,000 project was developed by the department store and banking executive H. C. Capwell in 1911 from plans by Charles W. Dickey, best known locally for his design of the Claremont Hotel. The Norman French interior decoration was attributed to Lancelot W. Suckert. The theatre was said to seat 1,200 on the main floor and another 700 in the balcony.

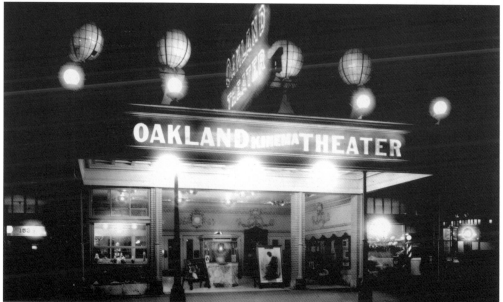

After a remodel, the five-year-old Oakland Photo Theatre adopted the name Kinema, a trendy British term for cinema. The 75-foot-wide frontage, seen here in 1917, was dominated by four crystal-ball lamps; gold medallions, stenciled in peacock blue, punctuated the "wiped" ivory walls. An advertisement touted the ventilating system as eliminating "blowing draughts or deadly chills or doctor's bills." As part of the buildup of downtown, Capwell replaced the theatre in 1922 with a larger commercial building.

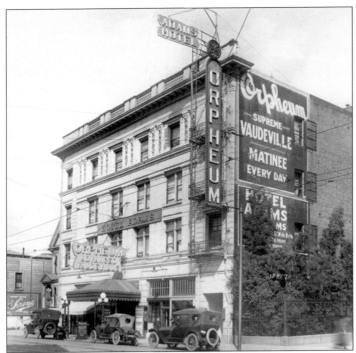

Four years after completing the Bell Theatre, Walter J. Mathews designed the Orpheum Theatre in the Hotel Adams building, which opened in 1907 on Twelfth Street between Clay and Jefferson Streets. Even though the theatre was never a financial success at this location, it was a very popular postcard subject, sent by the thousands in the 1910s. The theatre featured vaudeville and screen novelties. Vaudeville houses were seldom without movies, which were used as chasers to provide a break in the program.

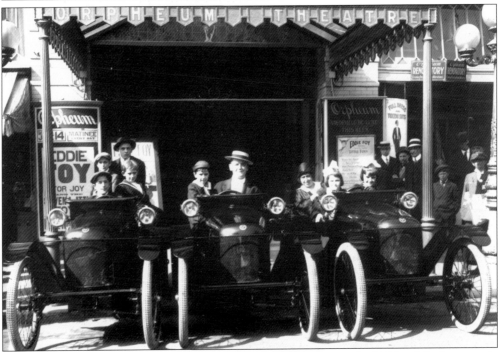

Vaudeville performers Eddie Foy and the "Seven Little Foys" pose at the Oakland Orpheum only a handful of years after Foy survived the disastrous 1903 fire at the Iroquois Theatre in Chicago. Comedian Foy, who was making up for his "elephant" act, rushed to the stage in a failed effort to restore calm. Foy narrowly escaped, but hundreds of women and children at the holiday performance perished. Bob Hope played Foy in the film version of his life released in 1954.

This Orpheum news and program is dated 1924, but the signature cover artwork was used for years by the circuit in the West, as well as in Canada and as distant as New Orleans. The Oakland distributor claimed that the program circulated each season to 702,000 "prosperous men and women" in the East Bay. The bill included the usual dramatic and comedic sketches, aerialists, gymnasts, singers, and of course, a photoplay that was shown twice daily before each live program.

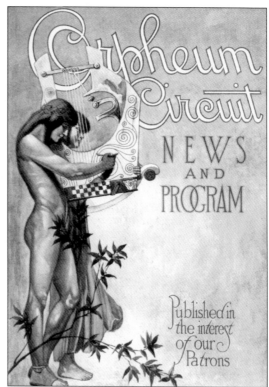

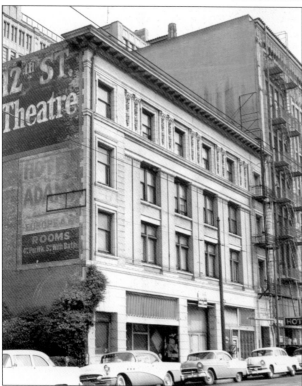

When the newly built Fox Oakland Theatre on Broadway was officially renamed the Orpheum in early 1925, this one became the Twelfth Street Theatre, later known as the Twelfth Street Follies. In 1927, the *Oakland Tribune* described this venue as antiquated and inaccessible. The Twelfth Street Theatre ended its days with burlesque and closed its doors for the last time in the late 1930s. After standing vacant for more than 20 years, it was finally torn down in 1958.

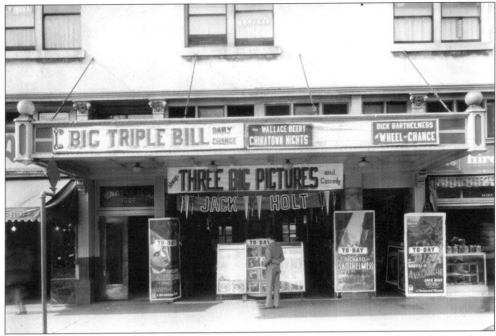

The Imperial Theatre, known as the Marlowe when it opened in 1908, stood at 1011 Broadway. In 1911, a member of the audience watching *The Poisoned Flume*, downed a fatal dose of carbolic acid in what may have been the first instance of life imitating celluloid art. In this 1929 view, patrons are offered three (silent) features and a comedy for 10¢ admission or 5¢ for children. They could purchase candy and nuts next door and take them in, hassle free.

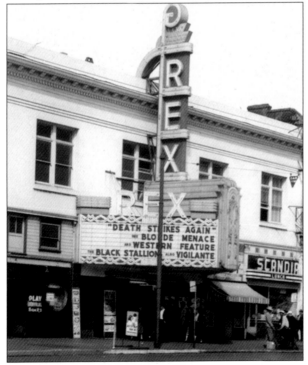

Thirty years later, the Imperial, now the Rex with its revamped modern vertical and marquee, is still offering three features, some of them renamed to disguise their age or identity. Few tears were shed when the Rex closed its doors for the last time in the mid-1960s. Its legendary flea circus was disbanded, and the building was subsequently torn down. Oakland's convention center now sits on the property. (Courtesy John Harder.)

The Pantages Theatre opened in August 1912 at 416 Twelfth Street. Alexander Pantages is credited with bringing high-class vaudeville to the West, beginning with a small-time operation in the Yukon. The claim is that this was one of the few theatres in which Pantages actually invested cash, and it was one of his pets. B. Marcus Priteca, who worked extensively with Pantages, was the architect. In the foreground, light reflects off the streetcar tracks.

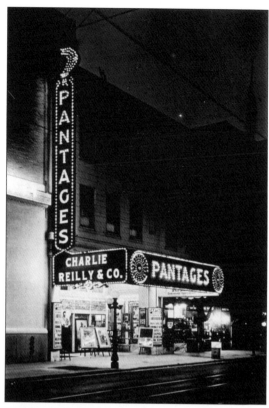

The drop curtain at the Pantages featured an idealized Oakland scene looking north on Broadway toward a flatiron building (one of two actually on Broadway). Oakland's banking institutions were on the east side of Broadway (at right). The portals at left, crowned by large spheres, are reminiscent of those flanking Rockridge Boulevard at the top end of Broadway. The clip on the back of each chair is for men's hats.

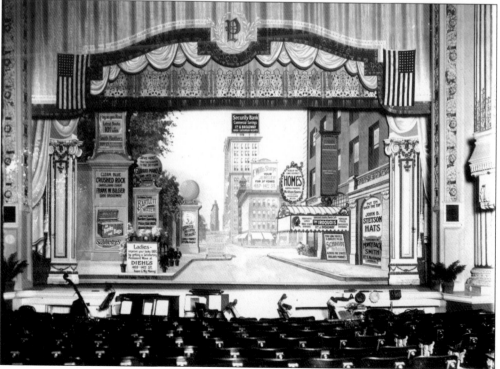

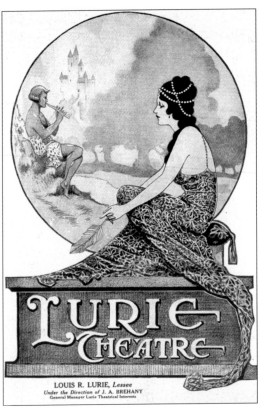

LOUIS R. LURIE, *Lessee*
Under the Direction of J. A. BREHANY
General Manager Lurie Theatrical Interests

The old Pantages shed its name when real estate man Louis R. Lurie acquired a 10-year leasehold in 1923. A company of 40 at the Lurie presented a "bombardment of lightning, dancing, mirth, music and melody" and "glittering glorious girls." Two years after his entrance to the theatre world, Lurie sold out to a man from Texas, who gave the theatre a Texas-sized name—the Hippodrome. Name changes yet to come in the 1930s were the Premier, Roosevelt, and Downtown.

The Storm Breaker is the feature (released in 1925) indicating vaudeville was now secondary to the film attraction. The Hippodrome operators probably hoped to cash in on the fame of New York City's Hippodrome, the largest theatrical structure in the world in its day. A lighthouse prop sits atop the marquee at the Oakland "Hip," as it was known. This is Oakland's second Hippodrome, the other being the former Ye Liberty Playhouse, which used the name briefly in the 1910s.

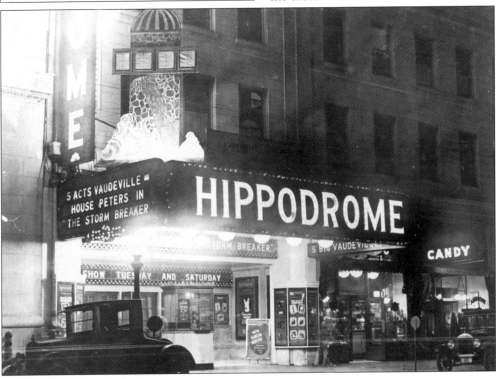

In 1939, there was another opening, another show, and another name change. The old Pantages became the Downtown, dressed up with a streamlined marquee and vertical sign in "daylight" neon. Jean Parker, a secondary actress recruited to smash a bottle of champagne against the box office, was joined by Budda, a radio personality. *For Love or Money* was a minor Universal release already in circulation for more than six months, so this was not as big an affair as it looks.

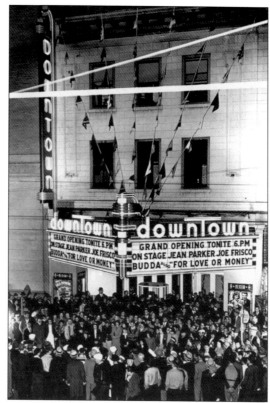

In 1942, the interior decoration of the Pantages still looked much the same as it had originally despite its many name changes. In 1939, wider and more cushioned seats replaced the narrow rows. Eleven proscenium boxes and loges that were part of the original seating remain. The new emphasis was on family entertainment, with an occasional stage show. The Pantages ended its run as the Downtown in 1946 and was remodeled into a newspaper plant for the *Oakland Tribune*.

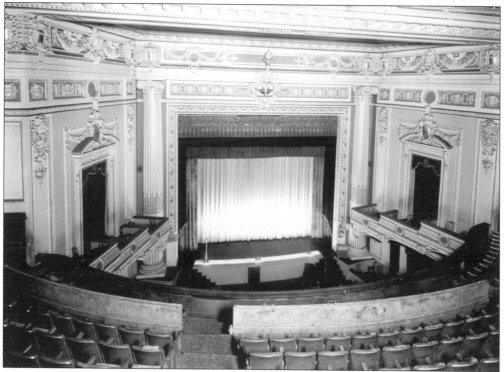

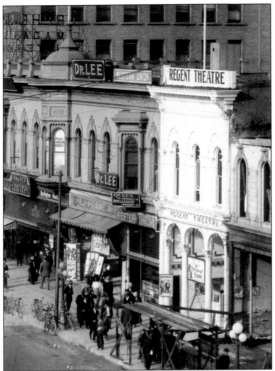

Passersby could choose between *On the Brink of the Chasm* at the Lyric Theatre (formerly the Novelty) or *The Vow of Ysobel* (released in 1912) at the Regent Photo Theatre. Both were one-reel films, running about 15 minutes. Other films of similar length would round out the bill to an approximate one hour's worth of celluloid. Each day, hundreds of pedestrians passed the two theatres, which sat near the junction of the Broadway and Twelfth Street car lines.

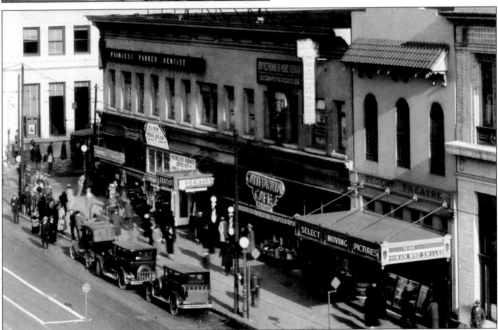

The Regent marquee in 1925 offered *The Man Who Smiled*. Stripped of its decorative plaster ornamentation, the Regent acquired Mission-style tiles plus a marquee canopy, giving it an entirely new look. The Lyric Theatre next door has been replaced by California Café and Bakery. Dentist offices were still upstairs, but Dr. Lee had been superseded by Painless Parker, a dental franchise operation.

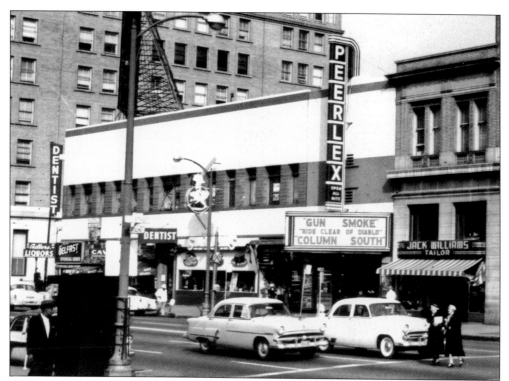

After spending the World War II years as the trendy Newsreel, the Regent was renamed the Peerlex Theatre In the mid-1950s, the Peerlex kept the turnstiles spinning by offering "Three Action Hits" for 50¢. Audie Murphy, the country's most decorated combat soldier of World War II, always seemed to be in least one of them, but here he was the star of all three.

By 1972, Bay Area Rapid Transit was in operation and so was the Regent, now rechristened the Pussycat, part of a chain that eventually numbered 45 theatres in California alone. The Pussycat segued from X-rated to XXX adult diversions, and by 1985, it was showing projected video due to a lack of film product. This was one of two Pussycat theatres in Oakland. After a 12-year process, the city of Oakland acquired this one by eminent domain in 1987.

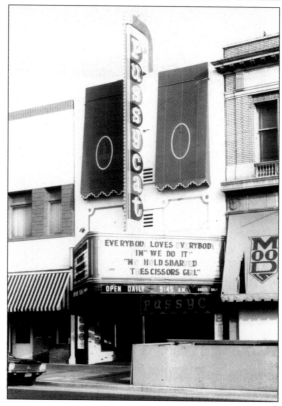

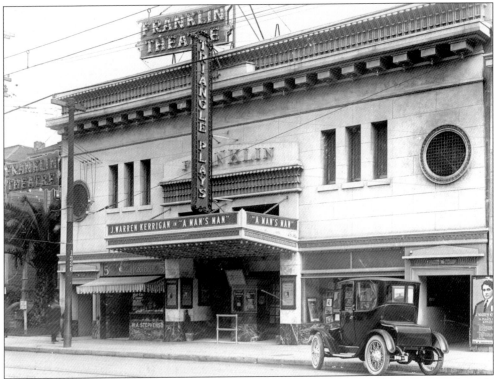

In 1914, the Franklin, the "temple of motion pictures," was built at 1438 Franklin Street exclusively for film presentation. Its architect was Chester H. Miller, who in a later partnership with Carl Warnecke designed the City Club (page 38). "Triangle Plays" refers to films distributed by Triangle Film Corporation. Pipes for the specially built Kimball organ flank the screen in this interior view (below). There is no stage, unlike previous downtown theatres built as "combination" houses with large stages for the presentation of variety acts as well as films. Because music was an important part of the silent-film program, an orchestra pit was provided for the original 10-member ensemble, then under the direction of Edgar Bayliss. The building was demolished in 1928 when Fifteenth Street was extended from Franklin Street to Webster Street.

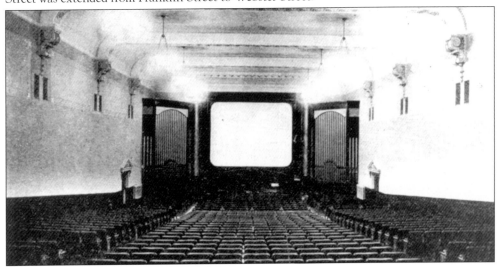

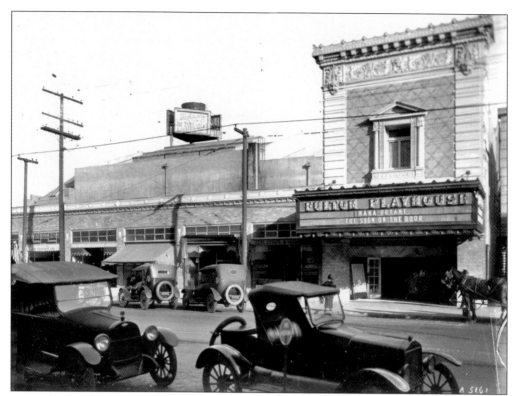

Located at 1518 Franklin Street, the Bishop Playhouse (later called the Fulton) was designed in 1916 by Edward T. Foulkes, who would later design Oakland's landmark Tribune Tower. The "most beautiful drawing-room theatre of Oakland" featured a revolving stage with close-in seating that gave it the intimacy of a little theatre. Three Oakland theatre personalities were involved in the Fulton: Harry W. Bishop; George Ebey (with Maude Fulton), who was also associated with the Orpheum; and Henry Duffy, who managed his own stock company.

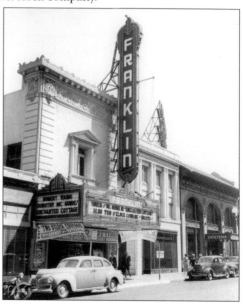

In 1935, the Fulton Theatre (formerly Bishop) reopened as the Franklin, a motion-picture house taking its name from the previous Franklin, which had since closed. The 813-seat theatre was a first-run house managed by the Carroll-Blumenfeld organization and during the World War II years specialized in newsreels and billed itself as the Telenews. When it returned to conventional programming, it resumed its Franklin name but closed soon afterwards and was torn down.

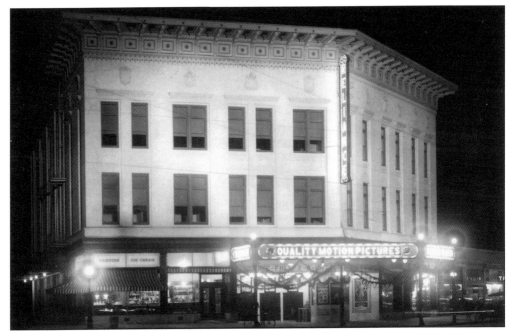

The Reliance Theatre at 1709 San Pablo Avenue at Clay Street opened in 1916 in a three-story brick building originally constructed in 1892. The theatre took its name from the conservative men's Reliance Athletic Club, a major social institution in Oakland once headquartered in the building. The tall, irregularly shaped structure dominated the surrounding uptown streetscape. The covered sidewalk marquee is similar to that installed at the Oakland Photo Theatre (see page 21).

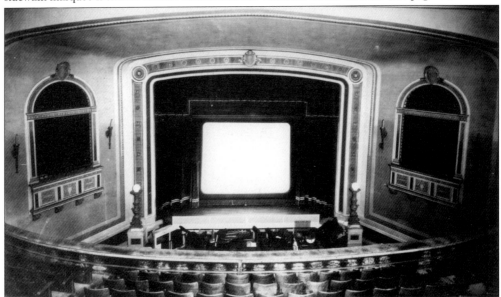

In this interior view of the American Theatre (formerly the Reliance), the screen appears to be very small in relation to the size of the stage. Light output limited screen size: larger screens demanded more light than the projectors could provide at that time. In 1918, evening prices were 15¢ to 20¢ with a few reserved seats going for 30¢. War tax was extra. The wood chairs pictured here were not replaced with plush models until 1939.

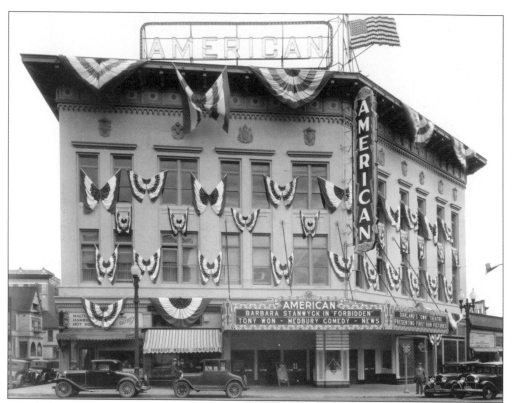

"Symbolizing the spirit of the times," the American (formerly the Reliance) celebrates a $20,000 upgrade to its audio system. The reopening in April 1932, featuring a Barbara Stanwyck film and a *Laughing with John P. Medbury* Vitaphone comedy short, drew throngs of people. The electric sign on the roof of the building was similar to those for the State and the Twelfth Street Orpheum, whose signs also sat atop office buildings on Broadway.

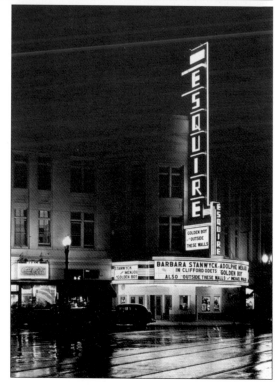

Barbara Stanwyck's appearance in both *Forbidden* (1932) and *Golden Boy* (1939) indicates not only her popularity, but the fact the 1,471-seat Esquire (formerly American) was an outlet for Columbia Pictures, a typical Blumenfeld "connection" that lasted until the 1960s. William Holden, who played the title role, was not on the marquee. This was Holden's "debut" film that brought him fame, but Adolphe Menjou was then the bigger star. After the Esquire closed in 1952, Mel's Drive-in was built on the site.

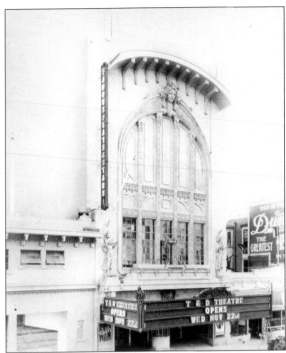

Turner & Dahnken Circuit's T&D Theatre, which opened in 1916 at 429 Eleventh Street, was purported to be the largest such theatre in the United States, boasting more than 2,500 seats. The architects were Cunningham and Politeo, who also did the Alcazar Theatre in San Francisco. The elaborate facade included huge stone jars that emitted steam and red lights, creating the effect of "sacrificial incense" burning. The tall vertical sign at left, reading "Famous Plays & Stars," indicates a contractual connection with Paramount Pictures.

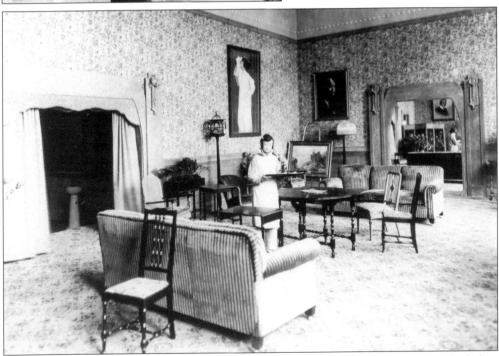

House conveniences in the T&D included public telephones in its Pompeian Room and a ladies' tea parlor, as pictured here. The room is decorated with ferns and paintings of movie stars. Behind the attendant is one of the theatre's many canary cages. (Not pictured is a large fish tank.) Although it was the custom of the day to tip lounge attendants, the T&D prohibited its staff from accepting any gratuities. One admission price included everything.

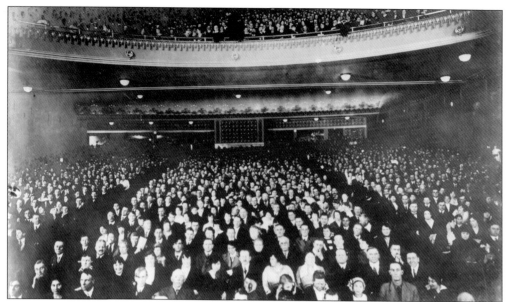

The T&D philosophy was to "raise the industry to a higher standard than nickelodeons." In this 1916 view, the well-dressed audience awaits the start of the feature attraction. They were also entertained by Cecil Teague and the 15-ton "monster" Hope-Jones Unit "orchestra." The organist was able to control the auditorium lighting, simulating sunset, morning, firelight, or moonlight. Later the organ was removed to the United Artists Theatre in Berkeley and from there to storage, where it remains to this day.

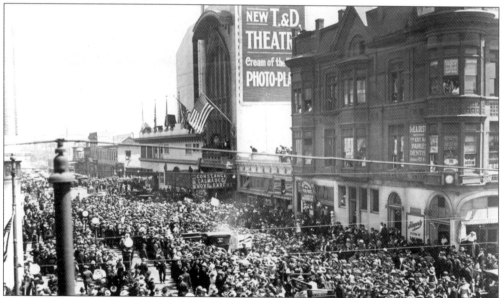

On July 26, 1920, crowds, including Oakland's mayor, welcomed producer-director Mack Sennett and comedy stars Charlie Chaplin, Agnes Ayres, Constance Talmadge, Coleen Moore, and Ben Turpin. Following the parade and a free show at the T&D, the crowd saw a baseball game between the movie comics and the Oakland Oaks, a Triple A Pacific Coast League baseball team. *The Love Expert* was a vehicle for the sophisticated comedy of Constance Talmadge, whose sister Norma was also a reigning silent-screen diva.

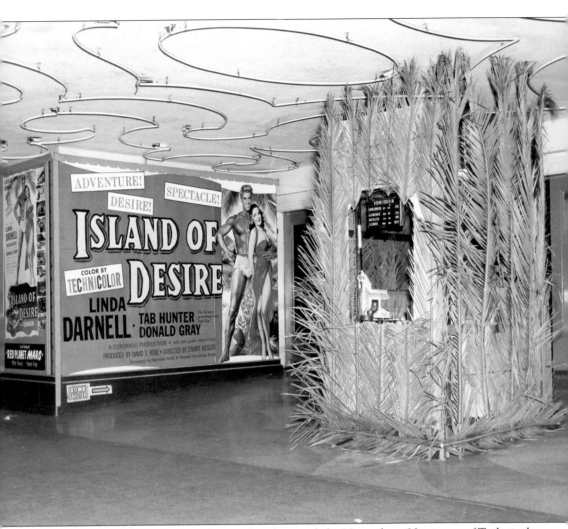

Palm fronds get theatregoers in the mood as they reach for 90¢ to share 90 minutes of Technicolor on the *Island of Desire* with scantily clad Linda Darnell and Tab Hunter. In the early 1950s, the T&D was "Open All Night" (until around 5:00 a.m.) and had been dubbed an "action house" by its operators, Blumenfeld Theatres, but was known colloquially as the "Tough and Dirty." In the postwar period, like other theatres, it was also designated an "air raid shelter."

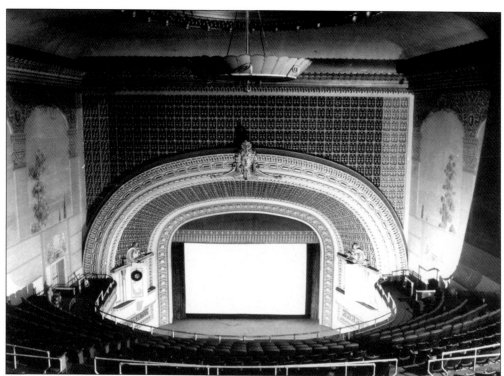

In the 1950s, the T&D was outfitted with a wide-screen while retaining its fading 50-year-old decorating theme of oranges and poppies, symbols of California. The stage was once equipped for live productions, which had been dropped years earlier. In an attempt to draw new audiences, the T&D hosted the John K. Chapel radio show, and during the 1960s, Blumenfeld also began promoting closed-circuit telecasts of important sporting events to sell-out audiences, so it did prosper in its own niche.

In 1973, it was the last hurrah for the venerable T&D, as well as many of its other similarly exhausted siblings elsewhere, as it seized upon the Supreme Court definition of obscenity, which gave legality, if not respectability, to nudity in films. It was a dismal period for the T&D in every sense of the word, and it was eventually torn down. The Trans Pacific Centre now occupies the former theatre site.

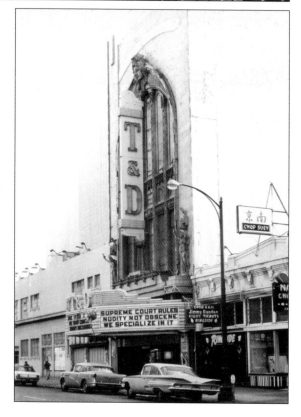

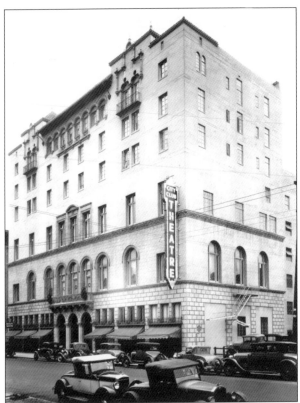

The Women's City Club at 1428 Alice Street was built in 1927 from plans by Chester H. Miller and Carl I. Warnecke. There were 75 guest rooms, three dining rooms, a pool, a solarium, tennis courts, and a theatre. In the late 1940s and into the early 1950s, the auditorium was used as the Paris Theatre in an unsuccessful attempt to bring foreign films to downtown Oakland. In recent years, the theatre has been a live showcase for various cultural groups.

The City Club auditorium was originally built for dramatic productions and concerts. The theatre was designed to seat 900. Its most striking element is the ceiling with beams of ribbed lath and plaster made to look like wood. On either side of the stage are simulated balconies with velvet drapes. Adjoining the theatre was a cocktail lounge and dance floor featuring live bands.

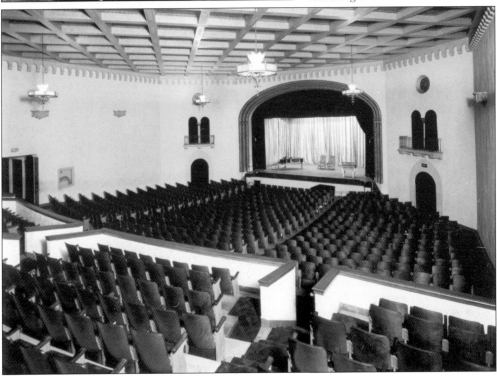

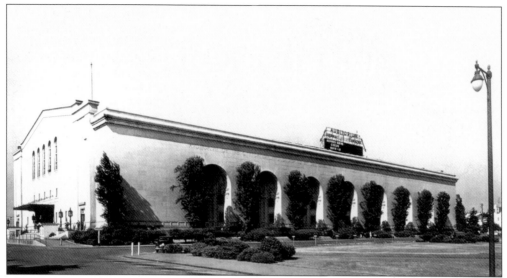

The Oakland Auditorium was built in 1915, at 10 Tenth Street, adjacent to Lake Merritt. Walter J. Mathews was general superintendent for the project, which was part of an ambitious civic improvement program. It was designed to accommodate several functions within one shell for audiences ranging in size from 150 to 8,000. The auditorium has had mixed success, partly due to its isolation and because the intended civic area never grew around it. In 1985, the auditorium was renamed the Henry J. Kaiser Convention Center.

Audiences came to enjoy professional sports, music, motion pictures, and theatrical events in the Oakland Auditorium's arena, theatre, and ballrooms. The Festival of Nations, the Oakland Symphony, and the Children's Holiday Pageant were among its traditions. The auditorium also hosted many conventions in the years before a new convention center was built on Broadway. This program is from a 1927 performance of the East Bay Opera Club, which was trying to establish itself in Oakland.

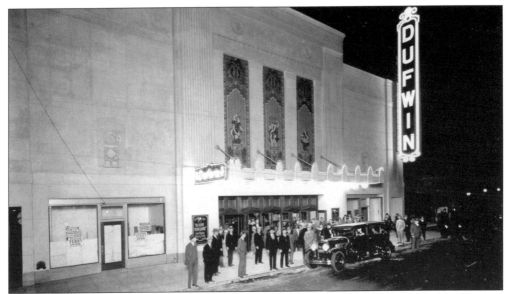

The elegant Dufwin Theatre at 517 Seventeenth Street was constructed in 1928 from plans by the architectural firm of Weeks and Day, whose other major commissions in Oakland included the Fox Oakland Theatre and I. Magnin store. Dufwin was a combination of the names of Henry Duffy and his actress wife, Dale Winter, who, as the Henry Duffy Players, operated nearly a dozen popular, legitimate theatres on the West Coast. The tile murals were manufactured by Gladding, McBean, and Company in San Francisco.

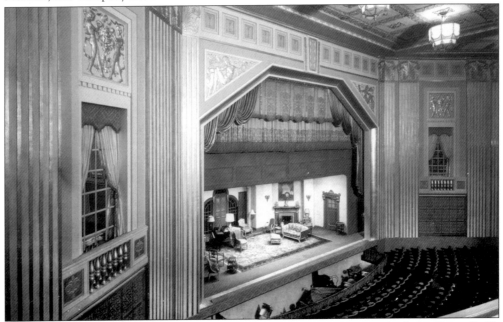

The interior of the Dufwin typified the polite and tasteful environment in which the Henry Duffy Players offered its presentations. The classical theme of the theatre was expressed in mahogany wainscoting, balconettes, fluted pilasters, and elaborate plaster motifs on the ceiling and proscenium. Geometric shapes contributed to the well-ordered décor. The octagonal form of the proscenium was carried to the light fixtures; wall panels were triangular and rectangular.

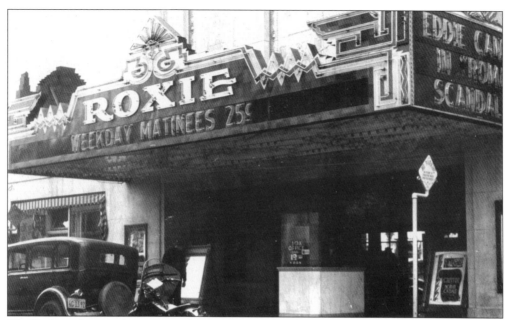

The Dufwin theatrical empire would crumble with the advent of talking pictures and the Great Depression. In December 1930, the theatre reopened as the Roxie. Note the neon marquee letters, a popular, short-lived, early 1930s trend. Each letter had to be plugged into appropriately spaced electrical outlets behind the readerboard, and breakage was a big problem. Most theatres soon abandoned the system, but the Roxie kept using them into the 1950s, one of the last known theatres to do so.

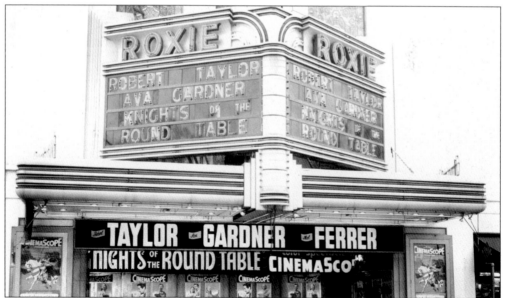

CinemaScope, a wide-screen image nearly twice the width of a standard screen, was introduced in the fall of 1953 with *The Robe*, first shown in Oakland at the Paramount Theatre. In early 1954, *Knights of the Round Table* was the Roxie's premiere CinemaScope attraction. In 1983, this 1,075-seat piece of Bay Area theatre history was converted into offices. The original tile murals were restored and preserved.

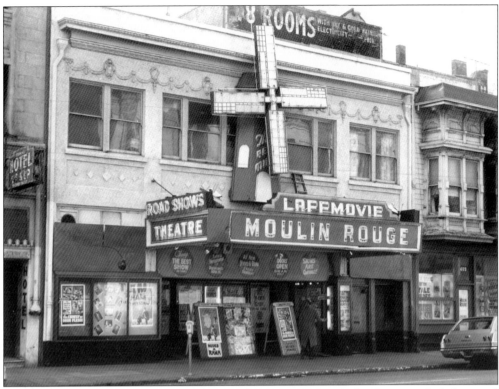

The history of this theatre at 485 Eighth Street begins in 1907 with the Gem, a nickelodeon and vaudeville house. In 1925, King Realty built an entirely new theatre at the site but continued to operate as the Gem. After remodeling in 1932, it reopened as the Moulin Rouge, a burlesque house. "Laffmovie" on the marquee is a reference to comedy films of the 1930s that preceded and later supplemented its more colorful reputation derived from its "girlesque" shows.

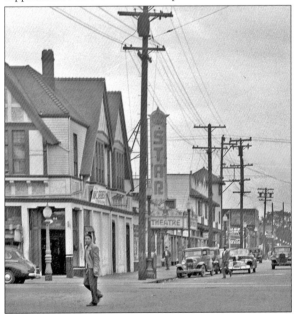

The 635-seat Star Theatre, located at 711 Market Street, was built in 1918, replacing an earlier theatre on the site. It opened as the Marquee, was renamed the Arabian, and then became the Star in the late 1930s. Other little theatres that had served West Oakland were the Palm, Linden, Adeline, and Majestic. In its last years, the Star was Oakland's first Spanish-language theatre. It closed and was torn down in 1964. The high-rise City Towers apartment building now sits on the site. (Courtesy John Harder.)

A Mission Revival–style nickelodeon and store building, constructed in 1914 at 1488 Peralta Street, was known as both the Golden Rose and the Peralta. In 1952, it became the West Coast headquarters for the radio ministry of His Grace King Louis H. Narcisse, D.D., whose motto, "It's nice to be nice," was installed in neon in the auditorium. A four-alarm blaze in 2004 severely damaged what was by that time known as the Mount Zion Spiritual Temple.

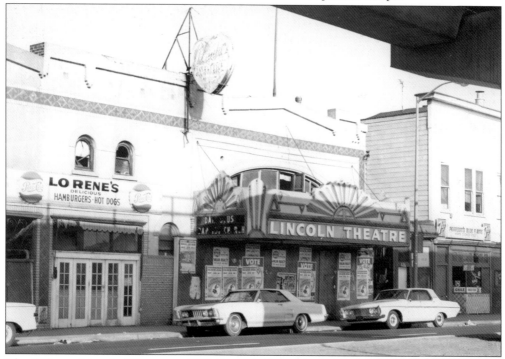

The 880-seat Lincoln Theatre at 1620 Seventh Street, built in 1919 by the King Realty and Amusement Company that constructed the Moulin Rouge and Palace, was the largest motion-picture theatre in West Oakland. In its heyday, Seventh Street was a lively entertainment and commercial district and social center for African Americans. In this photograph, the elevated transit line casts a literal and figurative shadow over the theatre used in its last years for church services. Following a 1998 fire, the building lay in ruins.

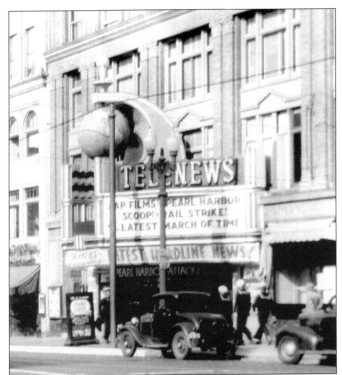

Located at 1906 Broadway, the 552-seat Fox News Theatre (later named Telenews) opened on July 3, 1942, having been converted from preexisting space by noted theatre architect S. Charles Lee. CBS news commentator William Winter delivered a radio broadcast on opening night from a studio set up to receive war news via international teletypes. In this 1946 view, Pearl Harbor films confiscated from the Japanese at the end of the war are hot news. In the 1950s, Telenews was rechristened the Globe, running mostly revivals.

Broadway acquired its last theatre in 1948. Like the Telenews, the Lux Theatre at 1220 Broadway was installed in an existing building. It was strictly a second- and third-run house. The Lux's snack bar, serving hot dogs and other tasty treats, was accessible to passersby on Broadway, adding immeasurably to the little theatre's revenue. It closed in November 1985 and has been recast as a retail store in a clever remodel that incorporates elements from the original theatre.

Jack London Cinema Center 3 at 201 Broadway opened as a triplex in 1973, one of Oakland's first multiplex ventures. Audiences failed to materialize for mainstream movies but turned out for newly emerging "adult" fare, such as *The Stewardesses* in 3D. It continued as an adult venue under the name Xanadu, operating "Twin X Adult Cinemas" that boasted the "Best in Erotic Video" 24 hours a day. The theatre survives today as an adult mini theatre, Secrets, with an adjoining video rental store.

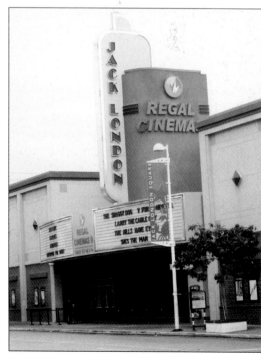

The Jack London Cinema at 100 Washington Street is currently Oakland's only multiplex and the only theatre built since the Paramount (1930–1931) that's still in operation. The 38,000-square-foot building features a 1940s-style tower outlined in neon. Designers Uesugi and Associates of San Francisco included an art deco–inspired lobby with café tables. Seating capacity in its nine auditoriums ranges from 101 to 352. Special soundproof walls and anti-vibration equipment reduce the impact of freight trains that run alongside the building.

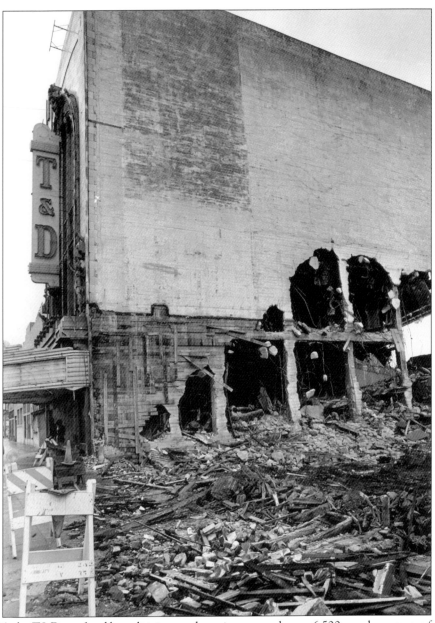

In 1916, the T&D was feted by politicians and movie stars, and some 6,500 people came out for the opening program. During its nearly 60 years of its existence, the theatre played host to millions of moviegoers and more than earned its place in Oakland theatre history. A beauty in its youth, the imposing structure stood through the Depression and two world wars; made the transition to the sound era, to wide-screens, and to closed-circuit television broadcasts; was open all night; and, in the end, celebrated the right to show adult films. In the final accounting, it closed because audiences stopped coming for a variety of reasons—the advent of television, changing tastes in entertainment, the deterioration of the once-inviting downtown environment, increase in crime, and flight to the suburbs, to name a few. Its job done, the T&D fell to the wrecking ball in January 1979 to make way for a new generation of buildings. The Trans Pacific Center now occupies the site on Eleventh Street. (Courtesy *Oakland Tribune*.)

Two

INTRODUCING THREE MILLION-DOLLAR THEATRES

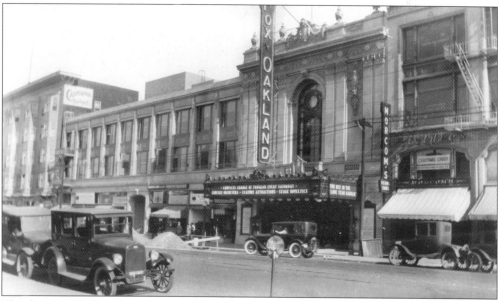

The first Fox Oakland, which opened on August 25, 1923, at 1730 Broadway, was hailed as a triumph of theatrical construction, the "Golden Theatre of the Golden West." The backers claimed that $2 million had been invested in the theatre building with "handsome" stores and two floors of offices, all designed by Charles Weeks and William Day. That partnership remodeled the State theatre the same year and would later design the Dufwin Theatre and San Francisco's Sir Francis Drake and Mark Hopkins hotels. The Fox Oakland was the first Pacific Coast theatre venture of William Fox, who was involved in film production, leasing, and exhibition. Fox contract player Tom Mix led a delegation of stars from the train station on opening day. The inaugural program began with the "1812 Overture," a stage spectacle with a cast of 35 called "The Festival of Progress," Fox news, a Fox "Sunshine" comedy, and a Fox feature, *The Silent Command*. Adult admission was 44¢ and 55¢ for loges. This chapter features Oakland's three million-dollar movie palaces of the 1920s—the 1923 Fox Oakland (later called the Orpheum), the 1926 Grand Lake, and the 1928 Fox Oakland.

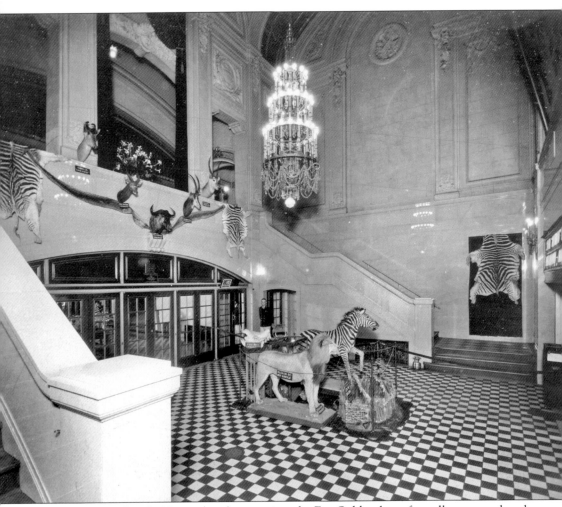

In February 1925, only 18 months after opening, the Fox Oakland was formally reopened as the Orpheum. The theatre became Oakland's big-time vaudeville house, but motion pictures were also a major draw. This lobby view is from 1930, the year after the Orpheum began offering sound and talking pictures using the RCA Photophone system. Stuffed animals were supplied by the distributor to add flavor to the lobby and make patrons think they were getting something special when they came to see *Ingagi*. Though the movie may not have been extraordinary, the Orpheum's soaring lobby was. It featured two marble staircases, a four-tiered glass chandelier, and dramatic floor treatment.

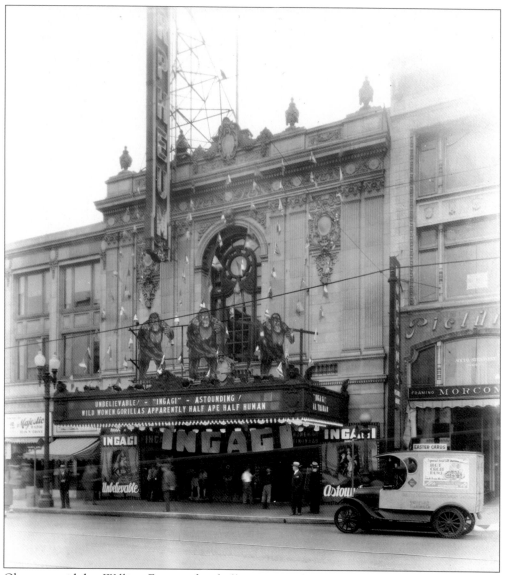

Observers said that William Fox was ahead of his time in selecting Oakland as a new theatre center because the theatre did not prosper, but under direction of the Orpheum circuit, which moved its Oakland headquarters over from Twelfth Street, it was a success and, for a time, was one of the biggest moneymakers in the chain. Evidence of the showmanship that made the theatre a success is in this photograph: the more extravagant the come-on, the more dubious what was waiting to greet the unsuspecting patron inside. *Ingagi* was a mock African documentary, put together in Hollywood mixing authentic African footage with contrived studio shots. It was supposed to show the capture of live gorillas, but along the way, somehow ape women were discovered. The *Oakland Tribune* drama critic had this to say, "Real or reel, *Ingagi* makes the sixty minutes slip by as so many seconds."

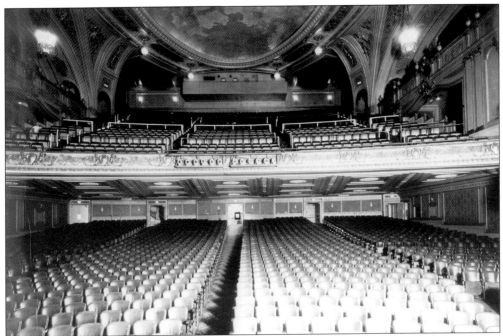

The local *Observer* magazine called the Fox Oakland the "glorious new shrine of the silent art." Said to be in the Louis XVI (or French) style, the classical décor featured beautiful murals, taken from Greek mythology and created by a large crew of artists and artisans. The ceiling lighting simulated the day, sunset, and night sky. Reds, gold leaf, and grays, with a touch of mauve, dominated the color scheme. Carpets, drapes, and hangings were rich, red velvet. Adding to audience comfort were the wider-than-normal seats and aisles. Main floor seats had armchairs with deeply upholstered seats and backs in a tapestry pattern with the rest of the 2,561 seats in leather. At the sides were arched promenades. A Moller pipe organ was installed for the opening.

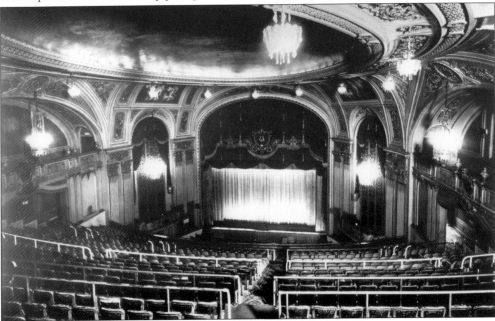

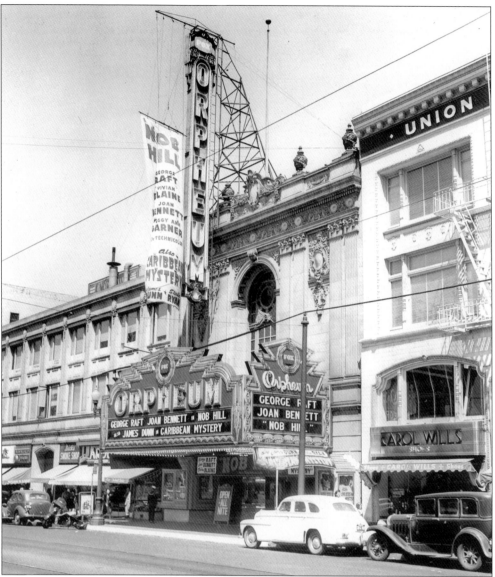

In 1928, the Keith Albee Orpheum circuit became Radio Keith Orpheum (RKO), combining what had been a vaudeville booking service and chain of theatres with motion-picture production. Even though Fox took back the theatre in 1933, Oaklanders simply called it the Orpheum. This photograph was taken in 1945 when the theatre was again under the control of Fox. The neon-lit art deco marquee featured the signature Orpheum logo in large cursive script with the Fox name above in smaller letters. To retain their appeal, theatres needed up-to-date marquees and facades, so in 1937, Fox hired Alfred J. Hopper to make alterations (costing $4,000). This is an updated version of the marquee constructed at that time. It survived on Broadway for years after the theatre closed, directing patrons to attractions at other nearby Fox West Coast Theatres.

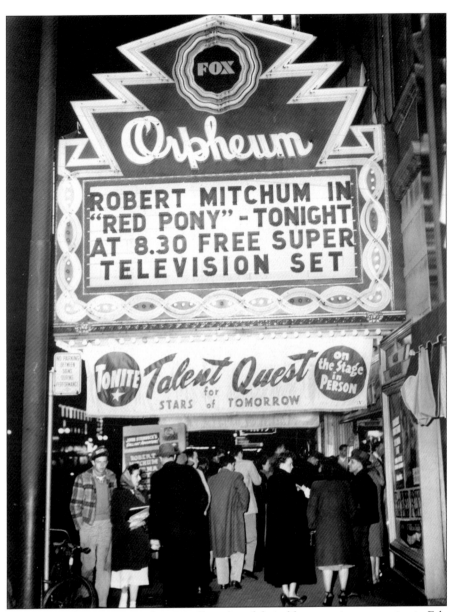

Going to a movie downtown at night was still a safe and desirable entertainment option in February 1949 when *The Red Pony* was shown. The marquee was brightened with a new coat of paint and neon, and the readerboard was changed from a black to a white background, with bevelite red plastic marquee letters. Ironically in a bid to boost sagging postwar attendance, a television was being given away. As broadcast offerings expanded, further inroads in theatrical attendance would occur. In November 1949, vaudeville was revived at the Orpheum in an effort to bring back the audiences of former times. Drama critic Wood Soanes wrote on the eve of vaudeville's return, "Of course it is quite unlikely that this will be 'vaudeville as we used to know it.' It is quite impossible to turn back the pages of entertainment history, and it is doubtful if there would be an audience for it." Vaudeville did not last and neither did the Orpheum. The theatre closed in May 1952, and, after sitting idle for more than a decade, was demolished in 1967 by the same firm that razed the Fox Theatre in San Francisco.

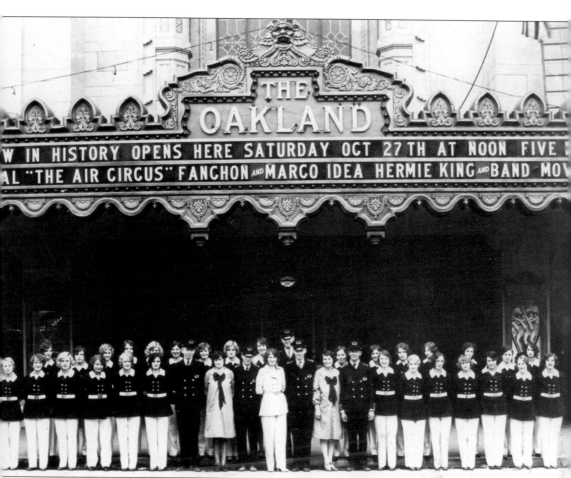

Smartly dressed staff line up before the Fox Oakland at 1819 Telegraph Avenue on opening day October 27, 1928. Among the staff of 150 that it took to operate the huge theatre was Esther Kelly (left of center wearing a big bow), who would also later sell tickets at the Paramount and Grand Lake. The talking feature presentation, *The Air Circus*, was special because only two other theatres in Oakland were equipped to show sound pictures at the time. Also on the program was a Fanchon & Marco "Stage Idea" titled *Up in the Air*, featuring stilt walkers, plus newsreels, an organ recital, and the 20-piece Hermie King band. Although the motion-picture house utilized the latest sound technology, the draw that day was the Fox Oakland itself, in which West Coast Theatres claimed it had invested $3.5 million. To bring the curious public to its newest showplace, the theatre operator paid fares for one hour preceding the opening of the Fox for all passengers on any of the 200 inbound cars and 43 busses within the Key System 7¢ fare zone. The *Oakland Tribune* reported this was a first. Fox joined two other theatres in the uptown district, the Dufwin theatre (opened three weeks earlier) and the Orpheum, all designed by Weeks and Day. To paraphrase Wood Soanes: where one theatre thrives, others will come.

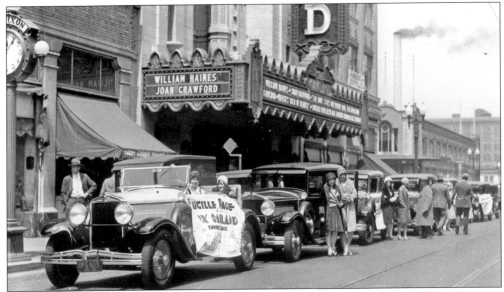

The star of an April 1929 stage show, Lucille Page is in the lead car to promote the opening of *Idea of Beauty*, a lavish Fanchon & Marco production that also included a 24-girl chorus line dubbed the "Sunkist Ballet." During this period, Fanchon & Marco presented a different show each week at the Fox Oakland: *Marble Idea*, *Broadway Venus Idea*, and *Sunshine Idea*, to name a few. The film showing is *The Duke Steps Out*, starring William Haines and Joan Crawford.

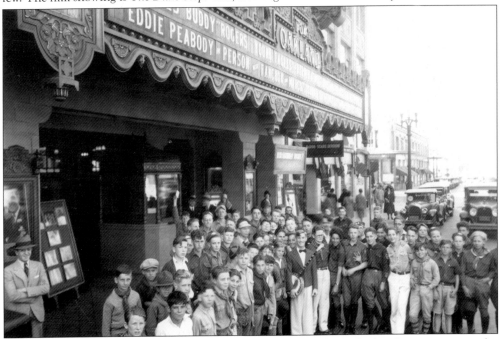

In April 1930, a lucky scout troop meets big time banjo king Eddie Peabody, who was very popular with young and old alike. The "wizard of the banjo" starred in Fanchon & Marco's stage show *Coral Idea*, which also featured a Samoan dance revue. The film *Young Eagles*, an early talkie in which air combats are both seen and heard, starred Buddy Rogers, who was then billed as "America's Boyfriend." Several years later, he would marry "America's Sweetheart," Mary Pickford.

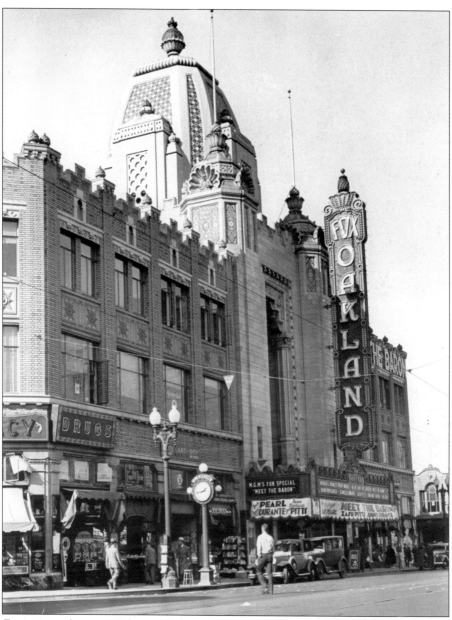

San Francisco architects Weeks and Day were commissioned to design the Fox Oakland theatre but shared credits with its builder, Maury I. Diggs, who designed the office wings. Diggs was a builder, engineer, and architect whose résumé included the racetracks at Golden Gate Fields and Bay Meadows as well as San Quentin Prison. Hindu architecture influenced the design of the complex central tower that steps back from the street and is encrusted with colored tiles. A crenellated parapet visually ties the wings to the building. As constructed, there were 35 offices and 15 shops. The president of West Coast Theatres said the architectural style was selected because "San Francisco is the gateway to the Orient and the wonderful country of India." At the gala opening, the *Oakland Tribune* published an architectural rendering that showed two vertical signs, but apparently only one was ever built. *Meet the Baron* was MGM's unsuccessful attempt in late 1933 to bring radio comedian Jack Pearl and his Baron Munchausen character to film audiences.

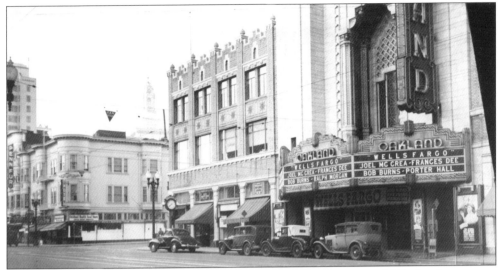

The Fox marquee was replaced in 1935 with this angled art deco version. Milk glass letters were lit from behind the readerboard, which is outlined in neon. In November 2001, restoration was completed to return it to this appearance, the goal being to keep the marquee and vertical sign (restored to a different era, in this case to its original 1928 look) lit every night to attract attention and to generate interest in the project, but its total renaissance is still many years and many millions of dollars down the road.

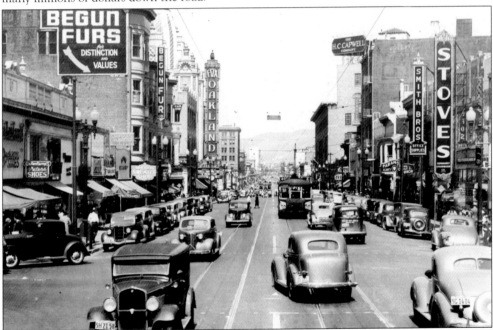

This 1938 view looks north toward the 1700 block of Telegraph Avenue. Traffic is humming, the Key System East Bay Transit Company streetcars move passengers along the route that ended in Berkeley, and there is not a vacant store in sight. The exotic Fox Oakland, with its terra cotta and buff-colored brick, stands in contrast to the wooden Victorian-era buildings and early 20th-century red-brick structures surrounding it, most of which disappeared decades ago. The H. C. Capwell building (right) survives today as Sears.

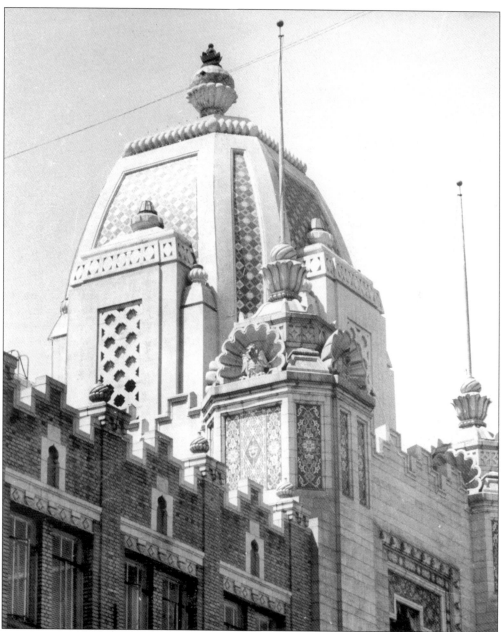

The four-story Hindu tower dome or "sikhara" was described by the *San Francisco Chronicle* as "typical of the Brahamanicao temple of Northern India." Others have called it a mixture of Indian, Moorish, Medieval, and Baghdadian styles. Consideration was even given to naming the exotic revival theatre the Bagdad. At one time, a Claude Neon beveled glass ball containing 125 feet of orange-red tubing (producing the equivalent of 20,000 watts of incandescent lighting) marked the building for passing air planes. Inside the tall foyer was a mural by Maynard Dixon titled *Goddess of Fire*. Patrons could ascend to the mezzanine and balcony levels via two deeply carpeted stairways or take one of two Westinghouse elevators. The Fox Oakland became a city landmark in 1978, and in 1979, it was listed on the National Register of Historic Places.

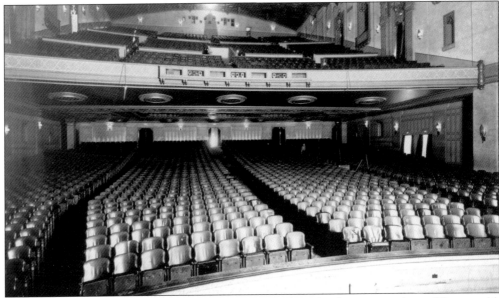

The 3,335-seat auditorium was photographed in 1945 when the theatre was almost 20 years old. The Fox was the first theatre in Oakland specifically built for sound projection. Equipment also included Westinghouse flood lamps and colored spotlights controlled by two boards that allowed rapid switching of lighting among five preset scenes. Originally blue draperies and colorful tapestries hung in the openings on the side walls. The gold-tone lighting fixtures were set with colored jewels, as was the richly colored Islamic-patterned ceiling that was inlaid with "scintillating" mirrors. Below the silver, gold, and green organ screens at either side of the stage sit two Hindu figures in bronze with "emeralds" and "ruby" jewels lit from behind, while wisps of steam rise from the golden urns cradled in their hands. The console of the WurliTzer pipe organ was installed on a platform that could be elevated eight feet above the orchestra pit and rotated 360 degrees.

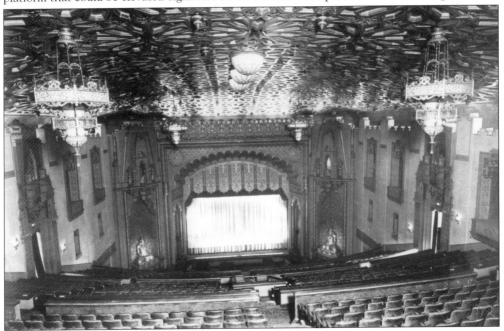

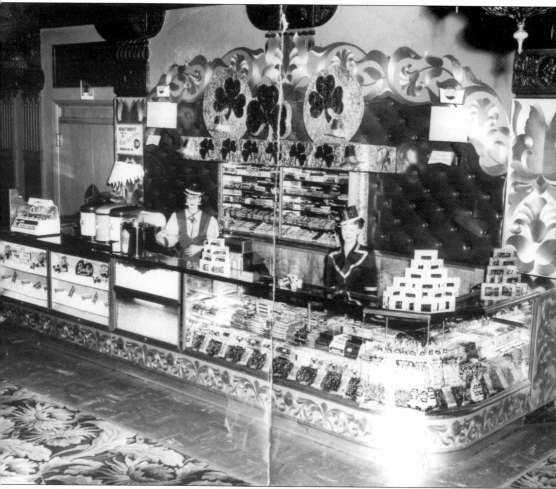

Candy counters arrived in most theatres after World War II. Note the prices in this 1949 photograph: a king-sized drink is 20¢, regular size is 10¢. Popcorn was sold in small 10¢ bags versus the big tubs sold today; optional butter cost an extra dime. In order to motivate theatre managers to bring in business, some circuits started giving them a percentage of the take on food sales, resulting in more and more extravagantly decorated snack bars as well as longer and more frequent intermissions for the beleaguered patrons. The names of the costumed counter attendants are not known. (Courtesy Terry Photo.)

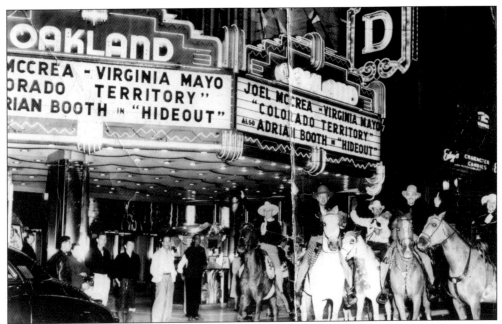

In June 1949, western riders make a personal appearance at the Fox to promote *Colorado Territory* in conjunction with the Metropolitan Horsemen's Association seventh annual horse show at Joaquin Miller Park. The western film starred Joel McCrea, who was an excellent horseman and one-time stuntman. This view shows the cloud ceiling added to the exterior lobby in 1947 and updates to the marquee.

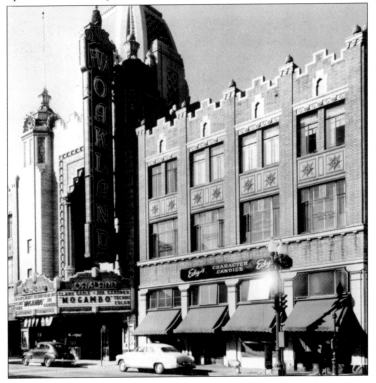

Business was brisk in 1953 at the Fox and at Edy's where "character candies" and "grand ice cream" made for memorable confections. Another Edy's store was located near the Grand Lake Theatre. Today Edy's is a brand name distributed by Dreyer's, but its stores are closed. Although shuttered for decades, the fate of the Fox Oakland is now considerably brighter—it has a new roof and new energy provided by "Friends of the Oakland Fox," who have a vision for this Bay Area landmark.

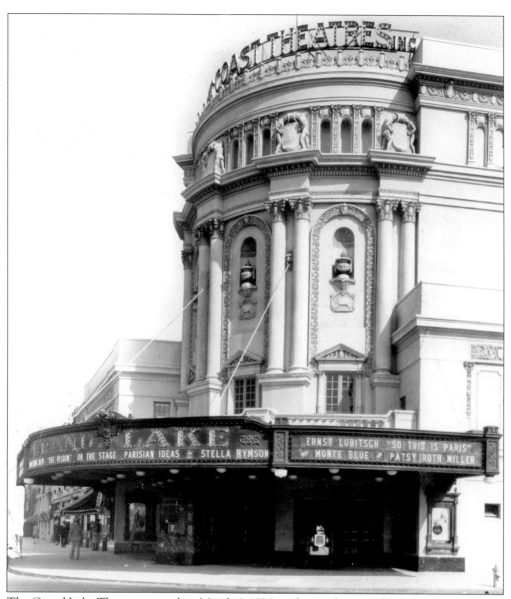

The Grand Lake Theatre opened on March 6, 1926, at the northeast end of Lake Merritt at busy Grand and Lake Park Avenues, near a district of fashionable homes. This photograph was taken in October 1926 when Ernst Lubitsch's *So This Is Paris* was the attraction. The imposing theatre, seven shops, and adjoining office structure was a project of West Coast Theatres, whose corporate name appeared in incandescent bulbs above the monumental 60-foot-high auditorium wing. Reid Brothers designed the stately Beaux Arts–influenced theatre with its rounded contour and elaborate cast-concrete ornamentation. Other well-known Reid-designed buildings are Hotel del Coronado in San Diego and San Francisco's Fairmont Hotel and Call Building. Theatre manager A. M. Bowles said in the inaugural program, "We have hoped to make that Grand Lake Theatre a center of the community in which we now take a part—we want to grow with you; to share in your progress and in your success." More than 80 years later, the theatre continues to anchor the neighborhood commercial district. In July 1981, the building and sign were designated city of Oakland landmarks.

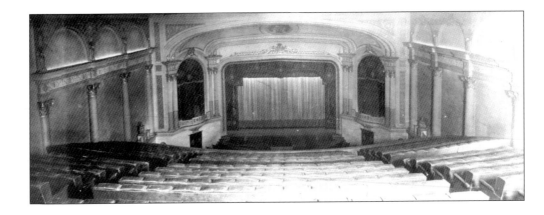

Building permits indicate an estimated cost (including signage) at $245,200, however, West Coast Theatres claimed to have sunk $1 million into the construction and decoration of the 2,177-seat Grand Lake Theatre. The Armstrong-Power Studios (Robert E. Power) oversaw interior decoration and curtain and stage equipment installation. Indirect lighting was by Harry L. Weber, specializing in theatres and amusement enterprises; seating by C. F. Weber and Company, San Francisco; and color illumination by Electric Specialty Company using "Reco Color Hoods." The main auditorium is flanked on either side by Corinthian columns, organ chambers are draped to look like private balconies, and it has an illuminated domed ceiling 75 feet in diameter. In this early 1940s view, the side wall landscape murals have been painted over. In 1981, the upstairs balcony and loge section was sectioned off with a 29-inch thick wall to create a second auditorium. Great care was taken to not disturb the architectural character of the theatre. The downstairs seating area has been refurbished and the colors brightened.

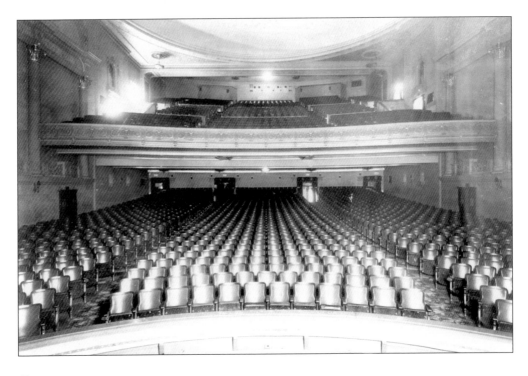

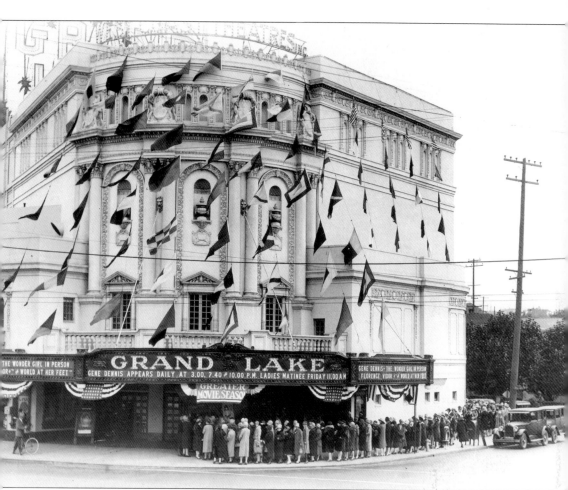

"Afternoons Out! Come on Downtown!" urged the West Coast Theatre advertisement that depicted a group of women waving good-bye to the maid and baby as they headed out for their afternoon on the town. Judging by the crowd, the advertising campaign worked. In 1927, a ladies' matinee draws a well-heeled crowd to see *World at Her Feet*. There are not many children in line, even though the Grand Lake had a nursery governess to care for small children while their mothers watched the movie. In addition to the film, there was a stage appearance by Gene Dennis, "The Wonder Girl" who "knows everything and she tells most of it." Apparently she also gave advice to members of the audience. The WurliTzer pipe organ was played regularly for patrons by Irma Falvey, formerly with Loew's Warfield Theatre. Note the French doors above the marquee, now partially hidden by the current marquee, which is taller than the original one.

WEST COAST

GRAND-LAKE
NEWSETTE

OAKLAND'S
THEATRE BEAUTIFUL

GRAND AVE AT
SANTA CLARA
NORTH END LAKE MERRITT

VOL. I. OAKLAND, CALIFORNIA, SATURDAY, JANUARY 1, 1927 NO. 34

Milton Sills, as a Dashing, Daring Desert Fighter, Comes to Grand-Lake in "The Silent Lover" Next

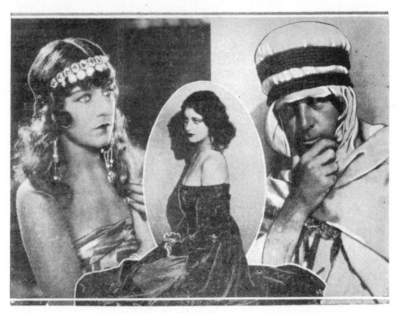

*Viola Dana, Charles Murray and Great First National Sup-
porting Cast Appear With Popular Idol in Desert Love Story*

"The Silent Lover," coming to the Grand-Lake Theatre next Saturday, gives Milton Sills a part ideally suited to his particular style of acting, that of a sternly-disciplined, hard-riding, quick-thinking young lieutenant of the French Foreign Legion, always ready for "a fight, a frolic or a flirtation," like our own famous Marines.

More than that—the hero has not one, but three romantic problems to solve during the action of the exciting drama—the first, which costs him his good name in the world of diplomacy; the sec-
(Continued on Page 2, Col. 2)

The January 1927 Grand Lake Newsette was typical of the programs available at many of the big theatres. The film companies provided the basic material, and then the individual theatres "personalized" them. They contained program notes, a synopsis of the films, and occasional brief interviews with actors. Film plots were also regularly carried in the Oakland newspapers so the audience would be familiar with the story. The attraction illustrated here is *The Silent Lover*, a film with no audio track; motion pictures with sound would not arrive at the Grand Lake for another two years. The actor Milton Sills is cast in a role similar to that created for Rudolph Valentino, who died the year this film was made. Sills would also face an untimely death in 1930. (Courtesy Allen Michaan.)

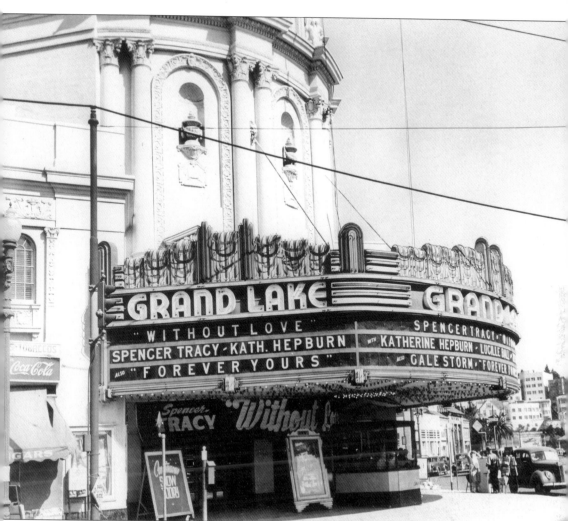

This 1945 view of the Grand Lake shows the art deco marquee installed in 1937 by Electric Products Corporation when a permit was issued to alter the marquee to form a new shape. It is larger, taller, and more elaborate than the 1925–1926 version. Double bills became standard fare in the 1930s and remained so in the 1940s and 1950s, along with a cartoon and newsreel. *Without Love* costarred Spencer Tracy and Katharine Hepburn in their third appearance together for MGM. Tracy always insisted on, and got, top billing.

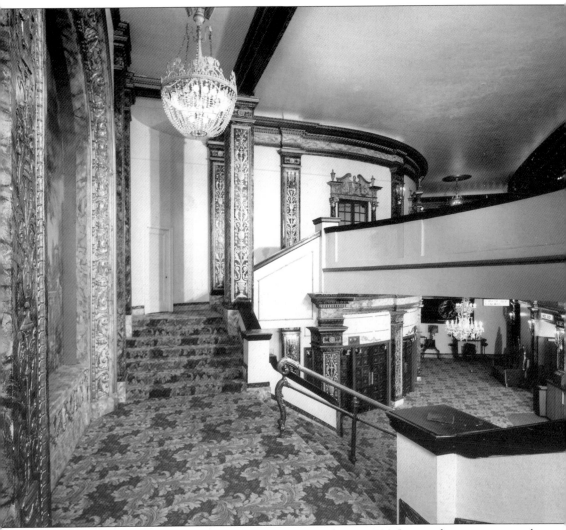

This view shows the Grand Lake lobby following an update in 1980. Its grand staircase is circular at the base with mahogany and brass railings. Square pillars, with low-relief plaster ornament that were once painted white and trimmed in gold, have been given a faux stone treatment in green. Crystal chandeliers, wrought-iron light fixtures, and electrical candelabras decorate both levels. The French door (seen at the top, mid-photograph) is one of several balconied windows that look down on the elliptical foyer. A large painting at the head of the stairs in an arched recess is just out of sight at left in this photograph. Sunset Lumber Company of Oakland supplied all the original lumber, interior finish, sash, and doors. (Courtesy Allen Michaan.)

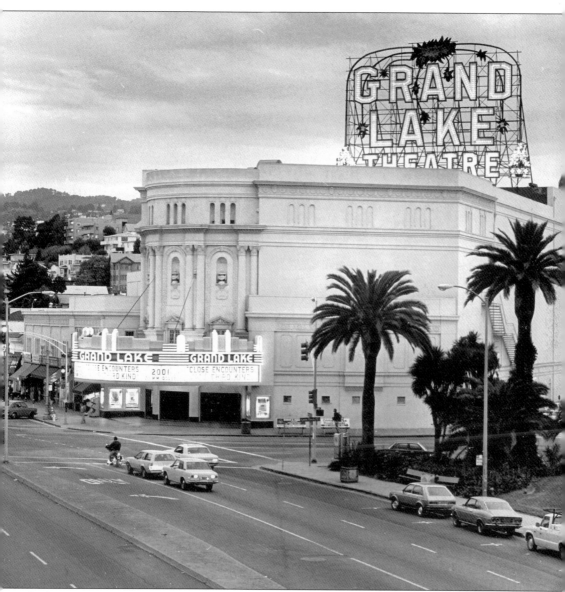

The large roof sign, with the theatre name framed by incandescent bulbs, was installed in 1925 by the Brumfield Electric Sign Company. The sign's electric motor turns a rotor, activating relays that control the animation of the lightbulbs giving the effect of exploding fireworks. Oakland theatres commonly had rooftop signs but none as elaborate as that at the Grand Lake. With a stated building permit value of $3,000, it was an expensive sign. Consider that in 1925, the building permit value for an average bungalow house was about the same amount. During refurbishment, nearly 7,000 bulbs were replaced in the sign, the marquee, and the exterior entry area. Note that in this 1980 photograph, the box office is now inside the building. (Courtesy Allen Michaan.)

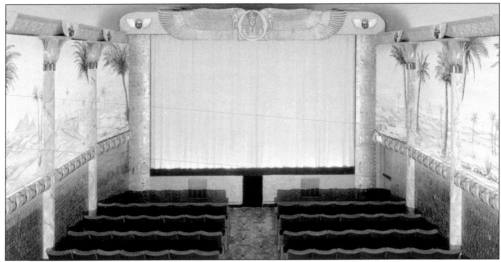

Much of the retail area of the Grand Lake was converted into two new theatre auditoriums in 1985. The vividly colored Egyptian-themed theatre (No. 3) and one with Moorish motifs (No. 4) were designed by Dusty Dillion and executed by his company Sculptured Wall Systems. Dillion is responsible for approximately 100 private and commercial theatre designs, including the fantasy-themed auditoriums at the Shattuck Cinemas in Berkeley and theatres No. 2 and No. 3 at the Orinda. The murals in the theatre pictured above are desert scenes with temples, pyramids, and Egyptian symbols. They were created off-site by a group of artisans and are installed over sound-absorbent materials. The floor carpeting pattern is stylized lotus flowers. A starry sky is achieved with fiber optics. The Moorish theatre pictured below features Bradbury and Bradbury wallpaper on the ceiling and carpets on the sidewalls. The columns and pillars in both theatres were molded of gypsum plaster. An earlier expansion in 1981 created a theatre in the main auditorium balcony, and with these additions, the number of screens at the Grand Lake grew to four. (Copyright © Tom Paiva Photography, www.tompaiva.com.)

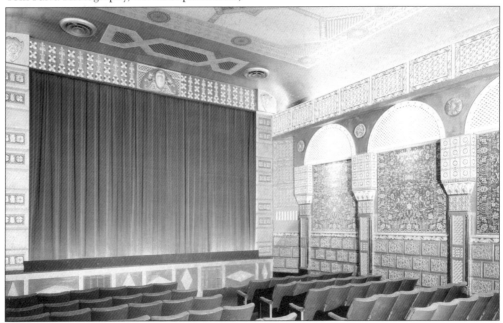

Three

FEATURING THE NORTHERN NEIGHBORHOODS

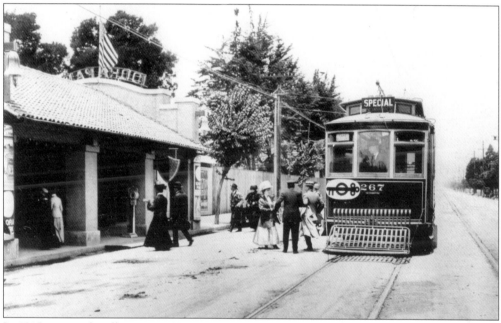

In 1915, a special trolley trip on Key Route Car No. 267, a 1902-built Lehigh type unit, unloads passengers during a summer weekend at the main entrance to Idora Park, located on Telegraph Avenue and Fifty-seventh Street. The 17-acre park opened in May 1903, the same month and year as Coney Island's Luna Park. Idora had rides, arcade games, a small zoo, daredevil stunts, a dancing and skating pavilion, swimming tank, restaurants, a movie theatre, an outdoor amphitheatre, and an indoor stage. It was a venture of the Realty Syndicate, which also developed the Claremont Hotel and Piedmont Park to stimulate streetcar ridership and land sales. Architect William Wollett used concrete in his design of the park entrance, pictured here, an amphitheatre inside, and several other park structures. Elsewhere in North Oakland, theatres clustered in the business districts at transportation hubs: San Pablo Avenue near Emeryville, Stanford Avenue at the Golden Gate neighborhood, Telegraph Avenue at Temescal, College Avenue at Rockridge-Vernon Park, and Piedmont Avenue.

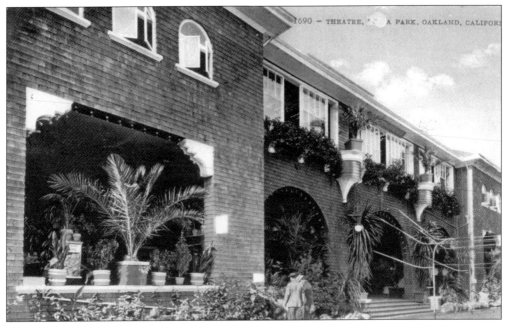

The first building at Idora Park was this shingled theatre begun in 1902 from plans by D. Franklin Oliver. The pavilion had two 64-foot towers facing Telegraph Avenue, and inside was a theatre with a three-sided gallery, a wine bar, and a dining room. The grounds were shaded by willows dating from the rancho days when the park was a picnic destination. Theatre attendance got a boost following the 1906 earthquake when San Franciscans discovered Idora Park. The theatre and grounds were leased to independent entrepreneurs who built and operated the concessions. During its opening season in 1903, minstrel shows were the main attraction, but in 1906, Harry W. Bishop of downtown's Ye Liberty Playhouse presented light opera with an opening bill of Gilbert and Sullivan's *The Mikado*. At that time, there was widespread interest in the Far East, as reflected in the Japanesque decorations at the park.

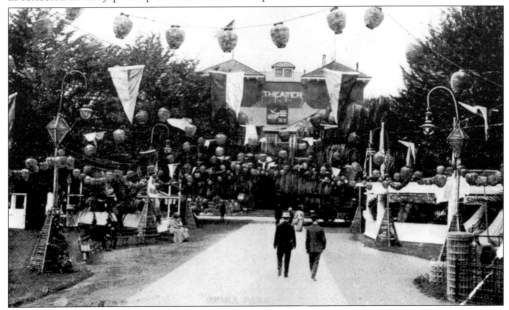

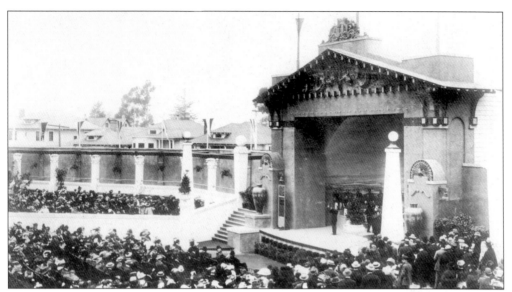

The capacity crowd at Idora's outdoor amphitheatre spills onto the wide promenade, pictured here in this 1909 postcard. The park operated only during the warm weather months, but due to financial difficulties, it failed to open for the 1929 season. Investors moved quickly to create the Idora Park subdivision at the site, with streets lined with quaint Tudoresque and Spanish Revival homes. The wood-sided houses beyond the amphitheatre just outside the park still stand on Fifty-eighth Street.

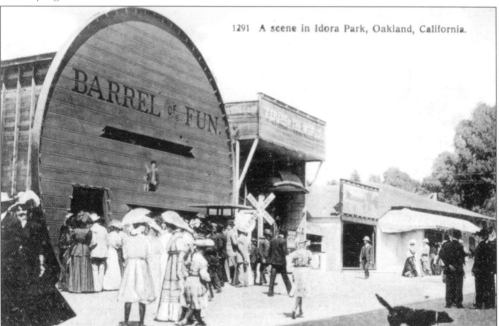

By 1907, Idora Park had 31 attractions. Two on the "Gladway" were the Barrel of Fun and Hale's Touring Car. Hale's (at the middle) simulated a train ride in which "passengers" sat in a railcar that lurched and rocked as scenery was projected on the "windows." It was briefly popular, but within a few years, interest turned from this novelty to projected films, and in 1911, a motion -picture theatre was constructed.

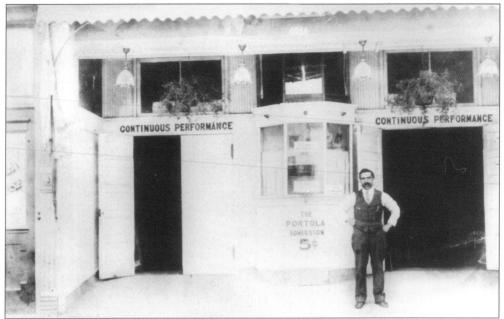

In 1911, Giovanni Zappettini stands in front of his nickelodeon theatre at 4914 Telegraph Avenue under a sign that reads, "Continuous performances admission 5¢." The theatre, built c. 1910 in a former general merchandise store, also operated as the Portola Theatre and Deluxe Photoplay. Directly across the street, saloon keeper Thomas D. Sullivan opened the Navajo Theatre in 1912. (Courtesy Joseph Brignole Jr.)

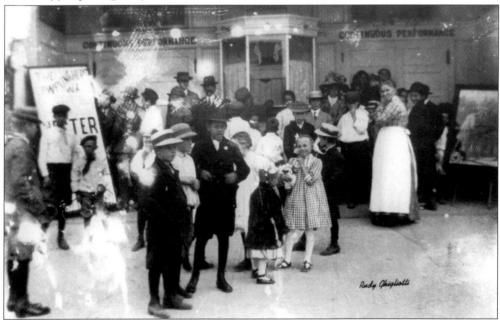

This is the matinee scene outside the Portola. Note the casual informality of the woman in her kitchen apron. The boisterousness of the children no doubt continued inside as audiences dropped in and out during the performances and people talked, while a piano player banged away at usually unscripted music that added passages of excitement, drama, and feeling to the projected image.

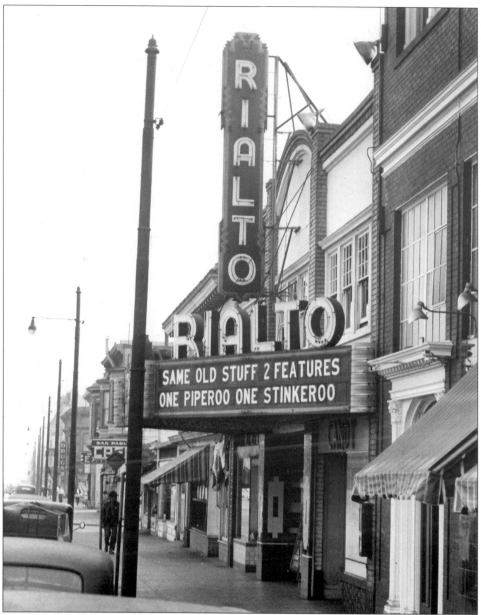

The 740-seat Rialto Theatre, located at 2723 San Pablo Avenue between downtown Oakland and Emeryville, was built in 1917, the second theatre on the site. When constructed, it was called the Avenue, and a candy kitchen and restaurant occupied the two storefronts on either side of the theatre entrance. This humorous photograph, a rare example of truth in advertising, garnered national attention in the 1940s when it ran in a widely circulated magazine. Unfortunately the Rialto came to an ugly end in October 1956 when violence broke out among youthful patrons who then attacked the responding police officer. The double bill that night was *Crime in the Streets* and *Screaming Eagles*. A subsequent investigation revealed that fire exits were padlocked, extinguishers empty and their hoses rotted, and 50 seats had been slashed open. Because the operator could not produce a business permit, the theatre was shut down. A few months later, the Rialto got religion when a church took over the space.

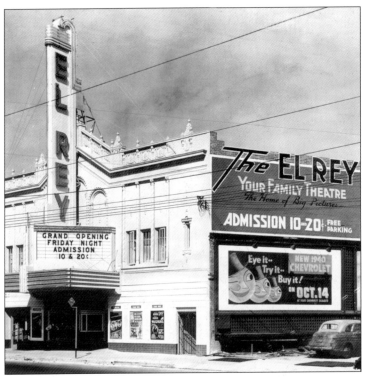

When the 700-seat El Rey opened on September 1939 at 3520 San Pablo Avenue, it was advertised as "Oakland's Newest Theatre." The fact is, it actually opened in 1926 as the Plaza and reopened in 1937 as the World; this was its third incarnation. The low, low 1939 prices were no doubt made possible by showing films in circulation for some time—*Waikiki Wedding*, released in March 1937, was two and a half years old, and *Algiers*, released in June 1938, was also well over a year old.

At its inception, El Rey (then called Plaza) was owned by a lumber company that leased it to Golden State Theatres. Until 1939, the program included a mix of stage shows and movies. From that point, it operated as an independent theatre offering family-oriented programming. Cash awards, merchandise giveaways, and low admission prices lured customers in the 1940s, but the location was bad, and survival was an uphill struggle.

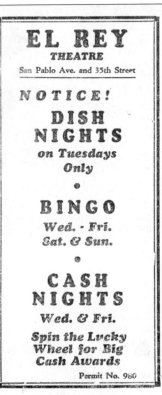

EL REY
THEATRE
San Pablo Ave. and 35th Street

NOTICE!
DISH NIGHTS
on Tuesdays Only

•

BINGO
Wed. - Fri.
Sat. & Sun.

•

CASH NIGHTS
Wed. & Fri.

Spin the Lucky Wheel for Big Cash Awards
Permit No. 980

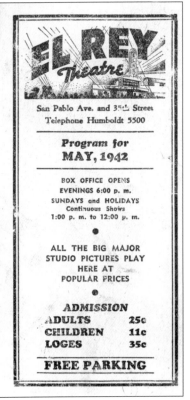

EL REY
Theatre

San Pablo Ave. and 35th Street
Telephone Humboldt 5500

Program for
MAY, 1942

BOX OFFICE OPENS
EVENINGS 6:00 p. m.
SUNDAYS and HOLIDAYS
Continuous Shows
1:00 p. m. to 12:00 p. m.

•

ALL THE BIG MAJOR STUDIO PICTURES PLAY HERE AT POPULAR PRICES

•

ADMISSION
ADULTS 25c
CHILDREN 11c
LOGES 35c

FREE PARKING

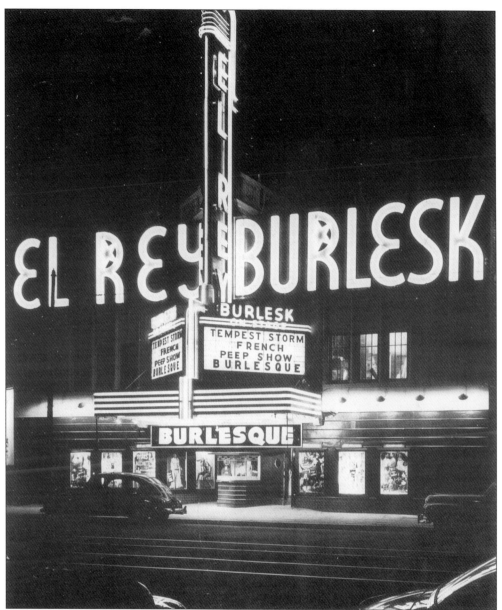

In January 1950, when "burlesk" was introduced at El Rey, the theatre proclaimed itself "world famous." Dancing to live music in the 1950s were many burlesque stars with stage names such as Countess de Risque, Lady Godiva, Rene Andres, and the well-known Tempest Storm, whose name alone appeared on the marquee when she was in residence. In an interview, Tempest Storm distinguished the theatrical audience for burlesque as being different from that in nightclubs, the latter drawing more women who were "more appreciative and better mannered." The theatre crew included musicians, a sound technician, and photographers who fed the publicity mill, the best known of whom may be Russ Meyer, who made his reputation and millions of dollars as a self-financed filmmaker of "skin flicks." El Rey, in the path of the proposed MacArthur Freeway, closed in July 1957 and was soon torn down.

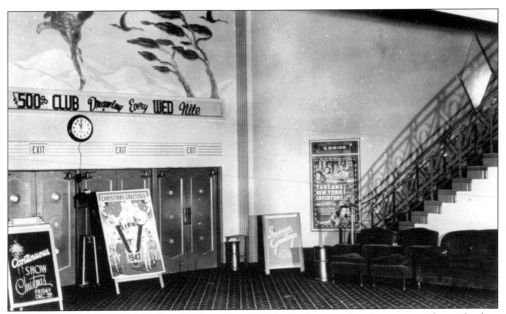

The Gateway Theatre (5810 San Pablo Avenue) lobby had a grand staircase on either side that led to an open mezzanine. Decorations included carpeting with warm, rich colors, "heroic-sized jars," and concealed lighting. Note the "V" for Victory on the 1942 Christmas greetings poster. *Tarzan's New York Adventure* was offered as a matinee attraction on Christmas Day. The $500 Cash Club drawing was being held at theatres all over Oakland.

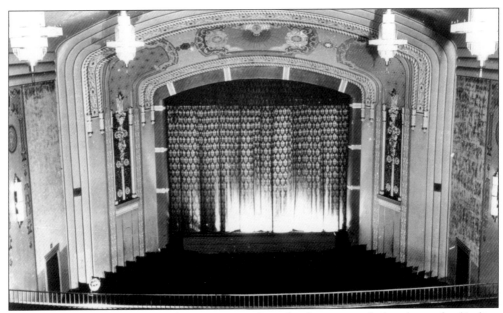

The Gateway ceiling was painted in a mosaic style said to be patterned after the work of Italian Renaissance artist Raphael. Indirect lighting in three colors provided an atmospheric touch. The theatre had a Smith-Unit organ manufactured in Oakland, and its stage was equipped for live performances. The ventilation system was supposed to be the best, however, during opening preparations, an employee improperly lit the oil furnace causing smoke to fill the auditorium.

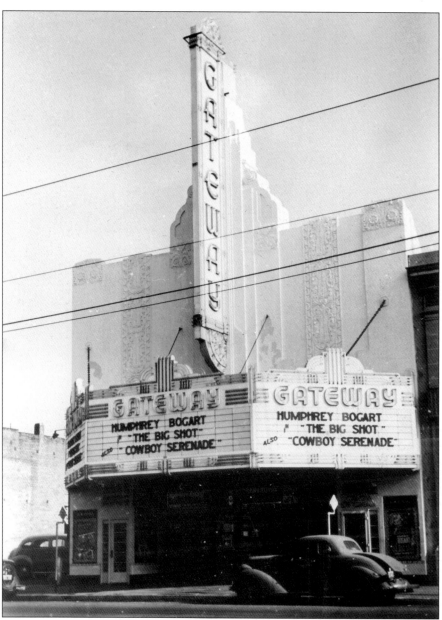

The 1,159-seat Golden State Theatre (later renamed the Gateway), built at the busy transportation hub of San Pablo and Stanford Avenues, opened February 1926 with *The Best People*, a second-run film that had already been premiered in downtown Oakland. It offered movies plus vaudeville on Sundays and musical comedy on Thursdays and Fridays. Architect Mark T. Jorgensen is credited with the original design, but like theatres everywhere, the facade was soon updated; in this case, in 1938 by builder Alfred J. Hopper from plans by Alexander A. Cantin. The opening of the Gateway ended the run of the 1910-era theatres in the district, including the Princess/Majestic and three associated with Joseph Weismann, who recycled the name Golden Gate at each location. The Gateway itself closed after nearly 30 years of operation and was taken over by a church, which incorporated the theatre and the bank building next door into a house of worship that is currently in use.

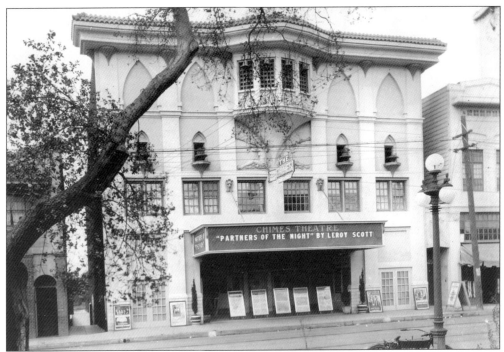

The Chimes Theatre at 5631 College Avenue featured four chimes in a projecting bay 40 feet above the sidewalk. This photograph was taken shortly after improvements were made in 1920 by architect James Placheck when the theatre was already three years old. Twin-seated figures sound trumpets beneath the bay while eight life-size figures inside embrace the themes of simplicity, strength, virtue, and light. The Chimes was the second theatre for the district, following the Rockridge Photoplay that opened in 1912.

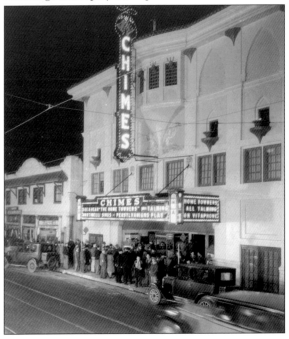

The Chimes premiered its first sound picture on February 14, 1929. Beach-Krahn Amusement had spent $1,800 on projection room alterations to equip the theatre for Vitaphone. Warner Brothers' release, the "100% all-talking" *Home Towners*, was an improvement over earlier sound films, which were actually silent with musical passages and occasional dialogue. At the gala reopening, the Pennsylvanians and tenor Giovanni Martinelli were heard in Vitaphone acts. Note the Chimes symbols on the two signs.

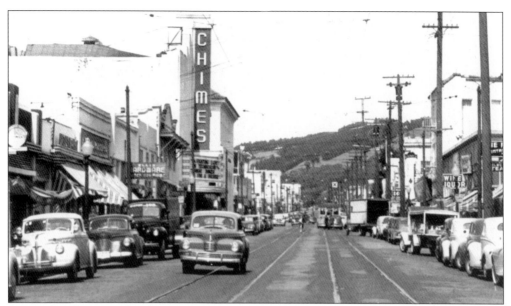

It is 1945 in this view of College Avenue looking toward Berkeley. By this time, more than $99,000 had been spent on alterations on an initial construction investment of $25,400. Patrons could park in the 50-car lot at the rear or take the streetcar directly to the door. The Grove-Shafter Freeway and Bay Area Rapid Transit now bisect the business district approximately where the streetcar stop sign hangs above the street. The Chimes was demolished in 1965 to permit these transit improvements.

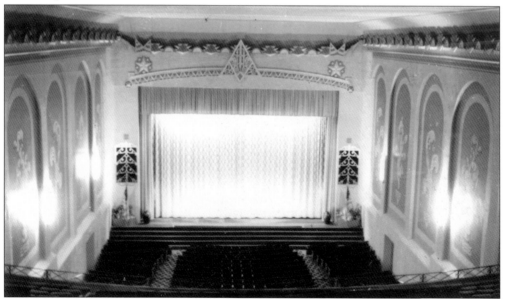

The Chimes was constantly evolving. The 1,276-seat auditorium with its art deco geometric elements is how it appeared in 1942. With Alexander A. Cantin directing, the theatre had been remodeled in 1930 (vestibule and stairs built, extended balcony and remodel facade) and again in 1940–1941 (facade remodel, bracing added, and new marquee). During the 1930s, it even temporarily adopted a new name, the Uptown. After the theatre closed, the second floor became Chimes Skateland in 1958, and a bowling alley was added in 1961.

The Piedmont Theatre was located at 3968 Piedmont Avenue in a two-story store, apartment, and nickelodeon building constructed in 1912. J. Henry Boehrer designed the building with blank windows above the theatre entrance (above, at right) to mirror those of the residence (above, at left). This was the second theatre for the avenue; the earlier one operated briefly in 1909. In 1917, Emil and Katherine Heber closed this venue and relocated to Sacramento. After their modest beginning in Oakland, the Hebers eventually owned three theatres in Sacramento. This building's current use is for retail. In the photograph above, the Piedmont is showing *Million Dollar Mystery*, a 23-part Thanhouser serial released in 1914 and 1915. Locals also remember seeing the popular Broncho Billy westerns made by Essanay in nearby Niles. The image below features actor Gilbert M. Anderson with rifle in hand in *Broncho Billy and the False Note* (1915). (Broncho Billy photograph courtesy Niles Essanay Silent Film Museum.)

THE VAMPIRE

A fool there was and he made
 his prayer
(Even as you and I!)
To a rag and a bone and a hank of hair
(We called her the woman who
 did not care)
But the fool he called her his lady fair
(Even as you and I!)

Oh, the years we waste and the
 tears we waste
And the work of our head and hand,
Belong to the woman who did not
 know
(And now we know she never could
 know)
And did not understand.

The fool was stripped to his foolish
 hide
(Even as you and I!)
Which she might have seen when she
 threw him aside—
(But it isn't on record the lady tried)
So some of him lived, but the most of
 him died,
(Even as you and I!)

And it isn't the shame and it isn't
 the blame
That stings like a white-hot brand—
It's coming to know that she never
 knew why
(Seeing at last she could never know
 why)
And she never could understand.

RUDYARD KIPLING

WILLIAM FOX Presents

A Fool There Was

BY PORTER EMERSON BROWNE

ROBERT HILLIARD'S GREATEST SUCCESS

PRODUCED BY
FRANK POWELL

FEATURING
EDWARD JOSE & THEDA BARA

RELEASED THROUGH FOX FILM CORPORATION

Alcatraz Theatre
TONIGHT
TUESDAY MAY 23rd
Adults 10c Children 5c

William Fox featured Theodosia Goodman of Ohio, renamed Theda Bara, as "The Vamp" who whispered, "Kiss me, my fool" in the Fox film *A Fool There Was*. This handbill, from stock produced for national distribution, was given out in 1916 by the Alcatraz Theatre located at 6384 Telegraph Avenue near the Berkeley-Oakland border. The film, made in 1914, premiered in New York City on January 12, 1915, and played at the T&D downtown an entire year before it made its way to North Oakland. Walking a few blocks north into Berkeley, where freshly released contemporary films also played more or less simultaneously with downtown Oakland, could have also afforded fans a faster look, which may well have been one of the reasons for the Alcatraz's early demise. During its short run, from 1913 to around 1917, the theatre was also known as the Colonial.

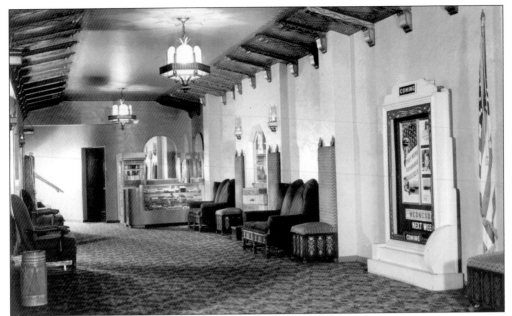

Except for the later addition of a candy counter, this is how the Piedmont Theatre lobby looked after a major remodel in 1934 by Alexander A. Cantin. The stairs at left led to the new balcony with loge seating where smoking was permitted. Patrons would often have to wait for a seat to open up, hence the comfortable upholstered chairs and ashtray. As built, a tiled water fountain provided the only refreshment for patrons, but the present-day lobby is devoted to food sales.

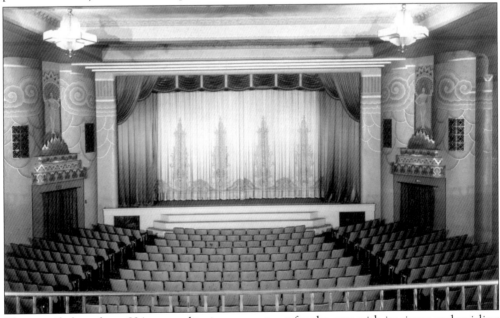

The stenciled art deco, 824-seat auditorium was a treat for the eyes with its zigzag and swirling images of water and fire, pagodas, and toga-clad women. An unfortunate triplexing in the 1970s resulted in two miniscule auditoriums being carved out of what was once the upstairs loge and balcony section, but the downstairs section remained relatively unchanged. Both the auditorium and lobby photographs were made in 1945.

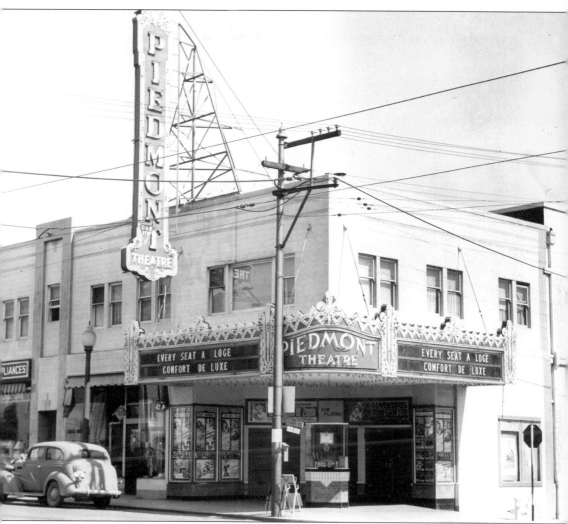

The New Piedmont Theatre, which opened in September 1917 at 4186 Piedmont Avenue, is the oldest operating motion-picture theatre in Oakland. It was the next step for its owner, musician and artist David Rosebrook, who had led a theatre orchestra that once appeared downtown at the American Theatre. The original auditorium had only ground-floor seating, but it did have the requisite WurliTzer organ. A short-lived device was the "pay-as-you-enter" system in which patrons dropped their admission into a box, eliminating the need for a cashier. Advertisements in 1917 promised "always eight reels" to a performance. This view was taken in 1945 after major upgrades a decade earlier had altered the original appearance.

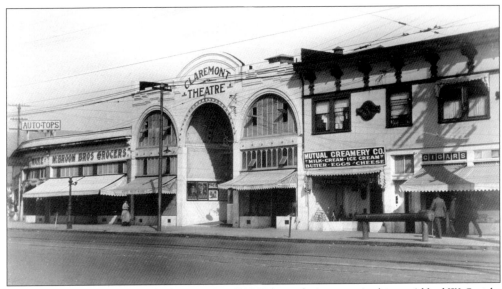

The Claremont Theatre was built in 1913 at 5110 Telegraph Avenue. Architect Alfred W. Smith, having just completed the Globe Theatre on Twenty-third Avenue, was commissioned to design the theatre by property owner Francisco (Frank) Armanino, a local wine and liquor dealer. The theatre was initially listed in the city directory as the LD (Lawrence Dorman) Purdy, named for its operator, a former car salesman. The neighborhood already had the Portola and the Navajo theatres and would soon have the New Central/Crystal.

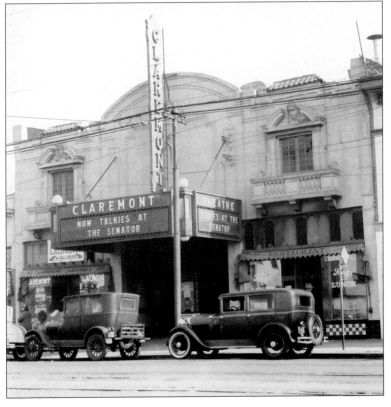

By 1929, only two years after a major remodeling by West Coast Theatres, the Claremont was shuttered as indicated by the marquee referring patrons to the nearby Senator Theatre, a larger and more elaborate nearby venue, which had opened in 1926 and was now offering the latest rage— talking pictures.

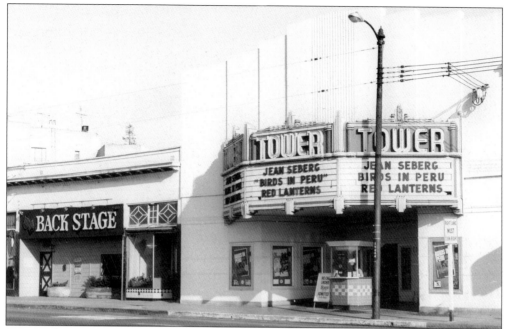

In 1939, the remodeled Claremont became the Tower Theatre. Thirty years later, in an attempt to fill a niche market, the Tower pitched itself as "Oakland's fine arts theatre." The notice reads, "No One Under 18 Years of Age Admitted to This Theatre," a great way to promote an otherwise boring import to a curious public. Released in 1968, *Birds of Peru* was one of the first films to receive an X rating from Motion Picture Association of America.

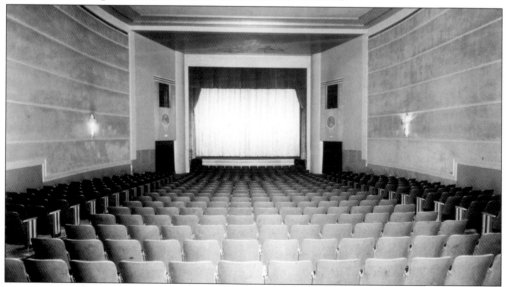

In June 1939, the new 600-seat theatre, built in the shell of the old Claremont, provided better acoustics and more style. The sparse update had horizontal lines, curved walls, and coved ceilings. The balcony was removed because it lacked appropriate fire escapes. In 1998, when the theatre was demolished, Tonalist murals hidden for nearly 60 years were discovered on the original walls. The day of demolition was a frustrating one for residents who wanted time to photograph and perhaps preserve them.

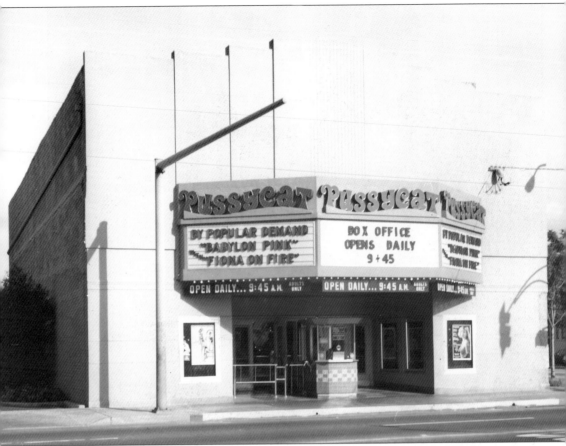

Neighbors often objected to theatres showing adult films, and the Pussycat adult theatre was no exception. The Tower Theatre switched to R-rated and then X-rated programming on January 1, 1976, with the double bill of *Sensations* and *The Seduction of Lynn Carter*. As the Pussycat, the interior was dressed up with red lightbulbs, paint, and carpet and red-flocked wallpaper. The Pussycat chain began in Los Angeles and, at one time, there were 750 theatres across the country bearing the name, although not all under control of the same company. Note that in this photograph, the theatre is now on the corner as a result of the widening of Fifty-first Street. Initially business was brisk because it was as close to the Berkeley campus as X-rated films were ever allowed to get. Beset over time by declining audiences lost to the video market, the Pussycat gave up in 1991. The theatre sat vacant for a number of years, then a January 1998 fire severely damaged the building, and the city demolished it the following December.

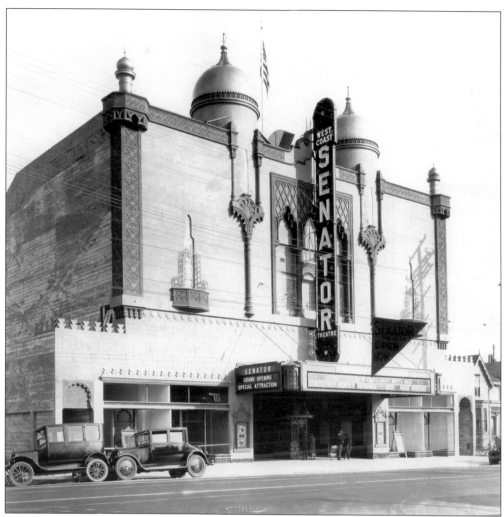

At the September 1926 opening, a parade of 5 floats and 30 decorated automobiles glided past the West Coast Senator at 3856 Telegraph Avenue. The mayor lauded the theatre industry for its contribution to the prosperity of Oakland and Irma Falvey, organist at the Grand Lake, gave a recital. Alexander A. Cantin was architect for the two-story edifice that featured twin minarets, four stores, and a big parking lot next door that patrons could use without charge. According to the press, the theatre represented an investment of $300,000, exceeding that of each of the other eight theatres built in Oakland that year except for the Grand Lake. Those two theatres joined the Plaza, Parkway, Fairfax, New Fruitvale, Gem, and Dimond whose building permits were all issued in 1925. Motion-picture attendance in the United States hit a new high of 50 million a week in 1926, and Oakland, just like the rest of the country, was in love with the movies, even though films had not yet learned to talk.

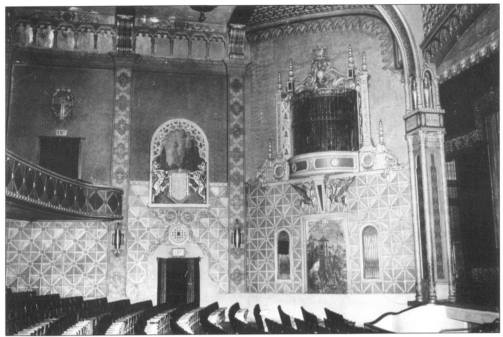

The Fox Senator was a second-run neighborhood operation but offered the best in theatre design and technology. The poured concrete side walls were painted to resemble stone and tile. The 1,624-seat auditorium featured Moorish ornamentation, stenciled designs, a balconette enclosing the organ grille, gilded mythological creatures, and idealized castle scenes depicted in tapestry-like murals, all decorated by Joseph R. Bailey.

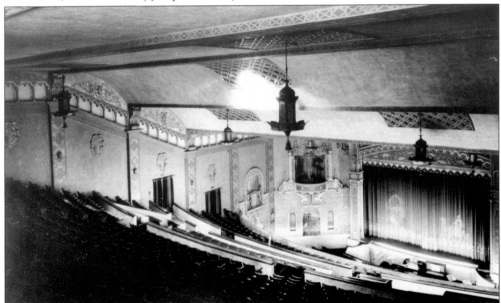

The Moorish theme of the Senator continued with a curtain depicting a caftan-robed rider on a camel and in the vaulted ceilings with screened panels. Beneath the stage, both the WurliTzer organ and a piano are visible in the orchestra pit. The broad balcony seated 200 more persons than the main floor, an unusual but not unique arrangement at that time.

This 1945 view shows the Senator marquee that was installed in 1937 by the Electrical Products Corporation. Alfred J. Hopper, who was doing alterations at theatres all over Oakland, also made some minor changes to the Senator around that time. "War Bond Promotions," as advertised on the marquee, were held in just about every theatre in the country and were an important part of the World War II era.

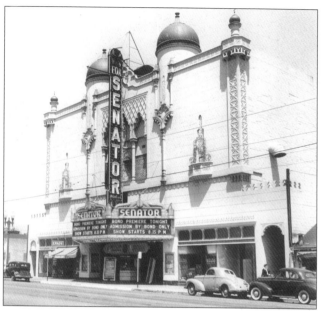

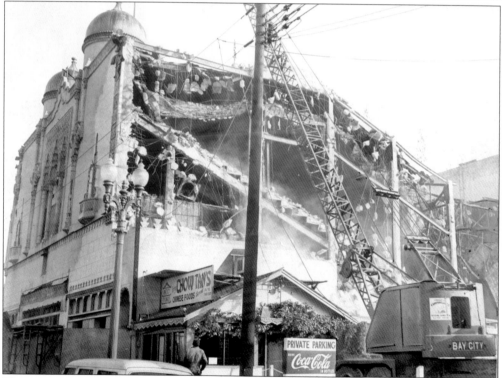

This January 1961 headline declared, "Curtain Rings Down on Old Fox Senator." It took several days to bring down the 900,000 pounds of concrete and 350 tons of steel that once were an exotic-themed movie palace. A reporter observed, "Everywhere in the nation old movie theatres are becoming bowling alleys, laundromats and parking lots." Two months after the lot was cleared, this property was purchased by a church that built an entirely new structure of a similar scale on the site.

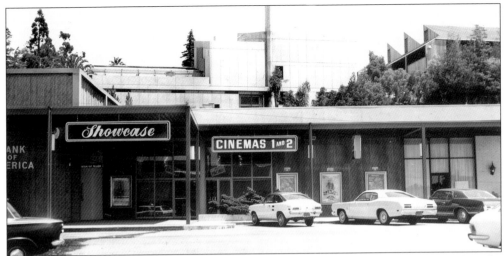

Don't make the audiences bigger, make the theatres smaller. Showcase Cinema opened in the Rockridge Shopping Center, c. 1969, and was soon joined by an even smaller venue next door (265 and 102 seats, respectively), hence Oakland's first twin theatre. In 1984, another trio named Showcase West opened in a former furniture warehouse at nearby Whitmore Street and Broadway. The largest of these three had seating for 275, while 160 and 175 could be accommodated in the other two.

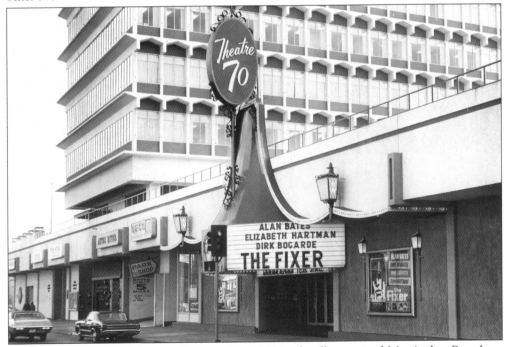

Theatre 70 (later called Cinema I) opened in 1967 in the ill-conceived MacArthur-Broadway Shopping Center. It was state of the art with box offices at both the MacArthur Boulevard entrance and inside the mall, which necessitated two cashiers. It also had rocking chairs, plush carpeting (even between the seats), 70-mm projection (though seldom used), and stereophonic sound. At first, exclusive first-run engagements such as *The Graduate* and *The Lion in Winter* drew crowds, but the theatre soon lost momentum and closed in 1978.

Four

OPENING EAST OF
LAKE MERRITT

Neighborhood business districts offered a full range of retail shopping and conveniences. This view of Park Boulevard includes a coffee shop; creamery; bike shop; drug, liquor, and grocery stores; a gas station; jeweler; and of course, the Parkway, the neighborhood theatre (right) anchoring it all. The Fruitvale, Melrose, Fitchburg, Elmhurst, and Dimond districts saw the rise of independently operated nickelodeons, beginning in December 1907 with the Star Nickelodeon, the pioneer of Fruitvale. In the mid-1920s, during Oakland's second theatre building boom, these little operations were supplanted by theatre chains that built midsized motion-picture houses, averaging close to 1,300 seats apiece. Golden State Theatres operated most of the new generation of neighborhood theatres in Oakland, and the districts east of Lake Merritt were no exception—Parkway, Palace, Dimond, Granada, Fairfax, Capitol, and New Fruitvale. Though designed by various architects, stylistically they tended to Spanish Revival influences, a popular architectural genre in that era. This gave way to art deco and streamline styles in the 1930s and 1940s. This chapter includes many Golden State theatres, plus the drive-ins, a shopping mall multiplex, and Oakland's only dome theatre.

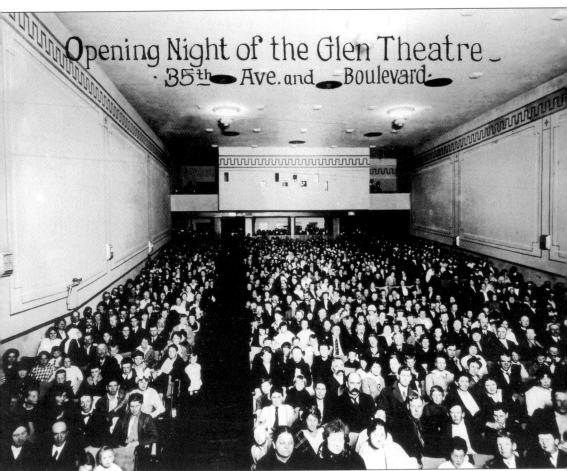

In 1916, a packed house awaits the start of the film on opening night at the Glen Theatre, located at Thirty-fifth Avenue and Foothill Boulevard. Going to the movies was an integral part of the social life of the neighborhood that was a weekly, even daily, ritual observed by one and all. Theatres could not be built fast enough or large enough to accommodate the patrons hungry for celluloid. The little auditorium designed to hold 687 was typical of the neighborhood motion-picture houses of the mid-1910s. Compare this opening to that of downtown's stylish T&D the same year (page 35). In the 1910s, there was usually little in the way of amenities. Patrons were lucky if a theatre had a decent ventilation system; however, the fire hose at left indicates the Glen was prepared should a film burst into flames. (See also California Playhouse, page 99.) (Courtesy Edmund Clausen.)

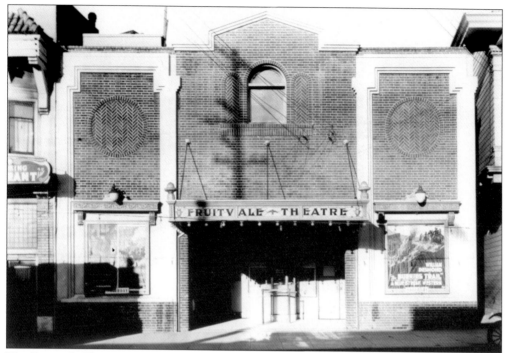

The Fruitvale Theatre at 1345 Fruitvale Avenue, constructed in 1912, was one of nine theatres opening east of Lake Merritt that year, and with its handsome brickwork, it was by far the most expensive with a $5,460 estimated construction cost. It succeeded an earlier theatre called Brown's/Fruitvale whose proprietor had complained of an inability to meet the weekly combined payroll of $80 for an operator, piano player, and stagehand.

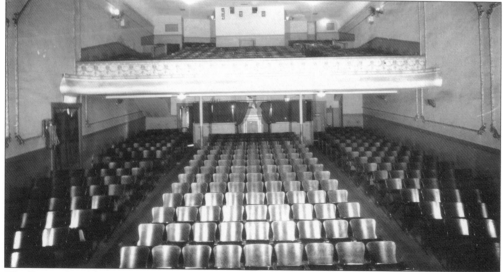

The Fruitvale auditorium was typical of the theatres built in 1912, the biggest year for new theatres in Oakland. It was an intermediate step between storefront nickelodeons like those that had preceded it in the neighborhood—Brown's, Fisher's, and Star Nickelodeon—and the larger more impressive structures like the one that followed it—New Fruitvale. The theatre operated for a dozen years, closing after the larger Dimond and New Fruitvale Theatres debuted nearby.

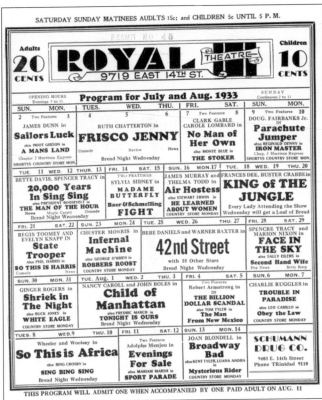

The Royal Theatre began operation in 1914 as John's. It was one of five motion-picture theatres that opened between 1911 and 1916 on East Fourteenth Street between Eighty-fourth and Ninety-eighth Avenues. This one hung on longer than the others, which had all ceased business by the time the larger Granada opened in 1924. A Depression-era audience builder at the Royal was a free loaf of bread for ladies on Wednesdays, and with the program changing every two to three days, why go anywhere else?

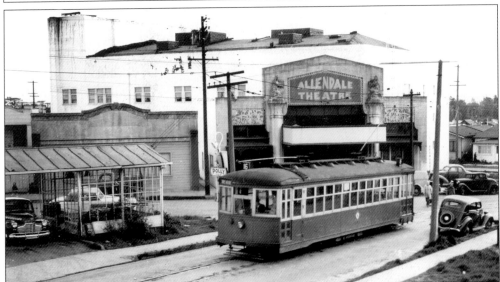

The Allendale at 2816 Thirty-eighth Avenue was constructed in 1927 at the end of the silent era. This photograph was taken on March 30, 1946, the last day of Key System streetcar service in the neighborhood. Three years earlier, the owner had converted the theatre to apartments when the influx of war workers put tremendous pressure on the housing supply. Now called Theatre Apartments, the auditorium has been retrofitted with two floors of apartments, but the building retains a theatre-like lobby.

The Parkway at 1834 Park Boulevard, dedicated on September 23, 1925, is the oldest operating motion-picture theatre east of Lake Merritt. Mark T. Jorgensen was the architect for this theatre, store, and office building with its eye-catching lattice-patterned facade, a big sunburst, and a roof sign, the latter with a building permit value of $500. Jorgensen also designed the State Theatre on outer Mission Street in San Francisco with a nearly identical facade.

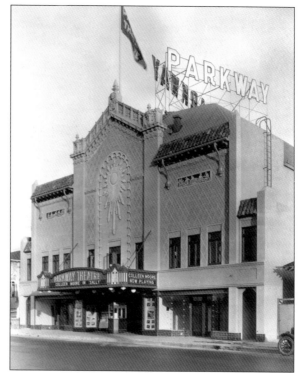

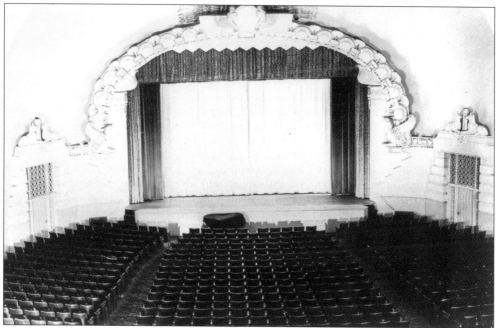

The Parkway organ loft is incorporated into the Egyptian-inspired sunburst grille work over the proscenium, while recumbent rams guard the exits. The WurliTzer style D had six ranks of pipes and percussions. Not seen in this view is the "crying room" with soundproof glass for mothers and infants. The 1,062-seat theatre was twinned in the late 1960s and reincarnated in 1973 as "Picture, Pub, and Pizza" with main-floor seating replaced by couches and chairs.

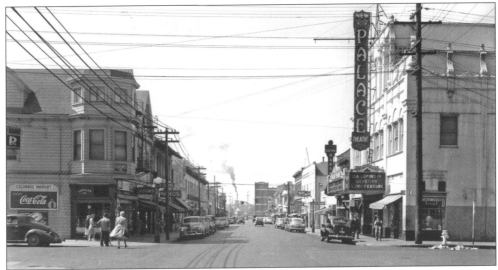

The 1,146-seat Palace Theatre, built in 1923 at 1445 Twenty-third Avenue, undoubtedly put the smaller Globe Theatre (located among the structures at left) out of business. This 1946 photograph looks southwest from East Fifteenth Street toward the business district that served the community living near the California Pottery Works and Oakland Cotton Mills, as seen in the middle distance. Allen King, later the proprietor of downtown's Moulin Rouge, established the Palace, which soon joined the Golden State chain. (Courtesy John Harder.)

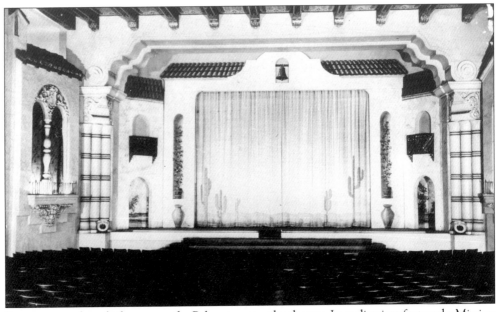

Patrons crossed a red-tile entry at the Palace to enter the theatre. Its auditorium featured a Mission bell, niches, balconettes, and an exposed-beam ceiling, giving it a Spanish Mission feel. The stage was decorated like a patio, with terra cotta jars and climbing vines; cactus plants on the woven curtain completed the theme. Since 1953, a church has made the theatre its home.

The Dimond Theatre stood at 3422 Fruitvale Avenue near MacArthur Boulevard. With the opening of the new theatre in 1926, the Dimond district lost its nickelodeon called the Liberty Theatre (previously Dimond Photo Play). Alexander A. Cantin designed the modern Dimond Theatre whose tower dominated the block of one-story buildings; its name honors Hugh Dimond, a pioneer in the district. The Dimond closed in 1953 and was reused as a grocery store.

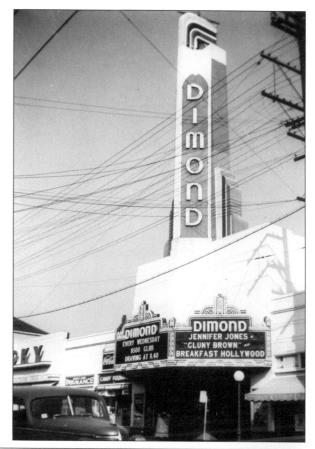

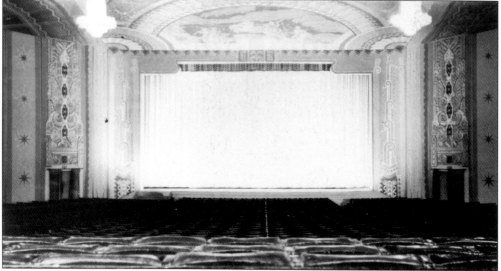

Wall murals and lighting were updates from the original Dimond interior, pictured here in 1942. The organ grilles had also been removed, probably at the time the theatre was outfitted for sound. Note that there is no balcony and that the comfy-looking loges (in the foreground) are on the same level as all the other 1,325 seats.

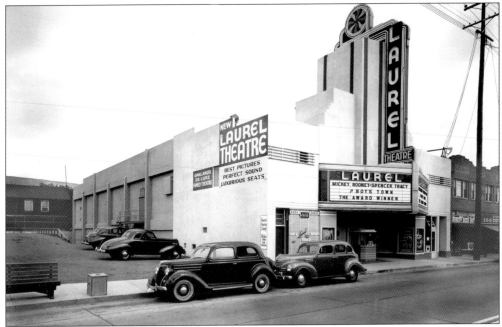

The team that brought about the Laurel Theatre at 3814 MacArthur Boulevard (formerly Hopkins) included architect Alexander A. Cantin and builder-developer Abraham C. Karski. The latter was also said to be involved in the development of the Grand Lake, Dimond, and Senator Theatres. This was the first new theatre building in Oakland since 1930, and it was Karski's "dream child." The central tower rises 44 feet above the sidewalk. Note that parking lots were becoming a necessary adjunct.

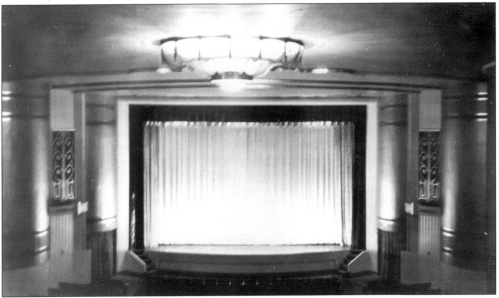

This 1942 view of the sleek and shiny 1,012-seat auditorium was taken by an insurance adjustor whose photographs of buildings had the unintended consequences of preserving Oakland theatre history for posterity. No live performances occurred here, but steps on either side of the narrow stage would be used by audience members participating in games played for money and prizes.

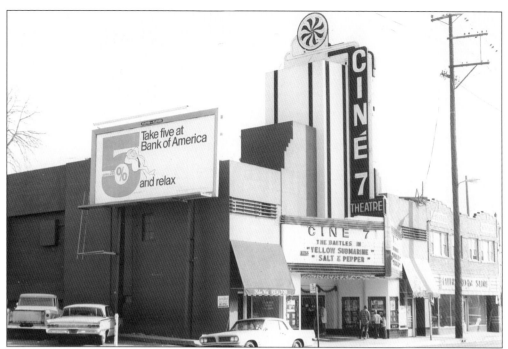

When the Laurel was renamed Ciné 7 in 1962, the idea was to bring art and foreign films to East Oakland, but audiences did not materialize and the policy soon returned to mainstream fare. Apparently whoever changed the marquee in 1968 was clueless as to how to spell the Beatles correctly. In 1973, X-rated films were introduced, and the theatre's business license was pulled in a struggle pitting First Amendment rights against neighborhood tastes.

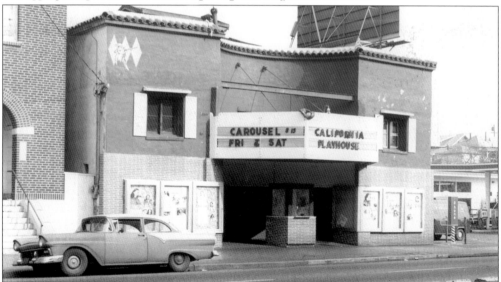

The Glen Theatre, designed by M. Lovens Newsom in 1915, had many names: Casino, Foothill, Studio One, and, as pictured here, California Playhouse, by now stripped of most of its original ornamentation. After several openings and closings, the building was boarded up. When the theatre was gutted in 1998 to be rebuilt as a Buddhist temple, a long-hidden lobby sign was revealed that said, "Everybody Welcome." (See also Glen Interior, page 92.)

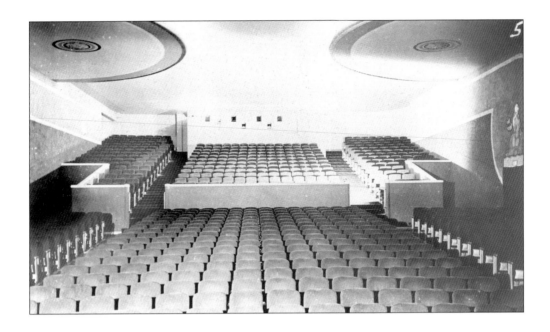

The uncluttered, streamlined, 892-seat Hopkins interior represented the new look in theatre design. Here it was interpreted in round and smooth shapes and flowing parallel lines that wrap around the auditorium. The seats all reclined with the balcony rising from the main floor stadium style. In 1953, the theatre was converted to a grocery store. Today it is a video and DVD rental store.

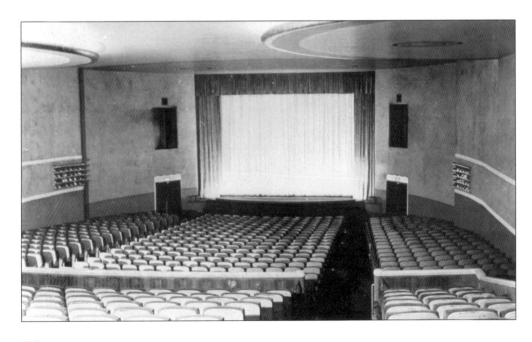

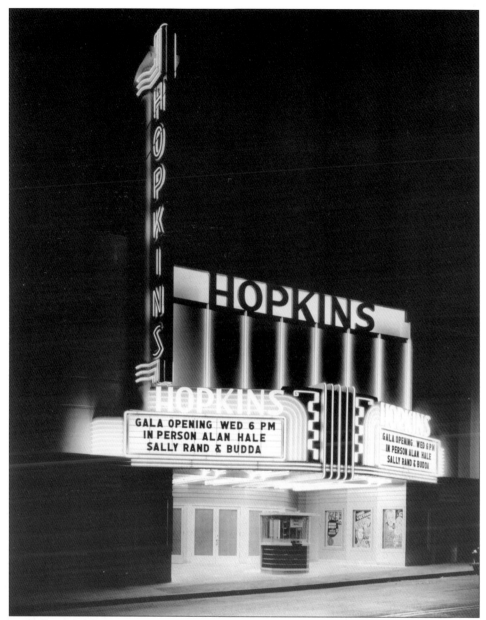

The Hopkins at 3529 MacArthur Boulevard (formerly Hopkins) was Oakland's first cinema built from the ground up before the materiel demands of World War II led to the cessation of theatre construction. The streamline moderne theatre was developed by Lawrence Goldsmith, owner of the nearby Allendale. Celebrities on hand for the July 1939 opening were Sally Rand, then appearing at the Nude Ranch exhibit at the World's Fair; Budda, a radio personality; and Alan Hale, who played Little John, Errol Flynn's sidekick in *The Adventures of Robin Hood*. An onstage wedding was also held, but there was more. A low-flying Goodyear Blimp dropped the films *Topper Takes a Trip* and *Dodge City* from a 500-foot elevation to the open arms of the manager or one of his minions, waiting breathlessly below. Considering that films were then shipped in 55-pound metal canisters and were printed on flammable nitrate stock, this must have been quite a spectacle and great unrealized entertainment potential.

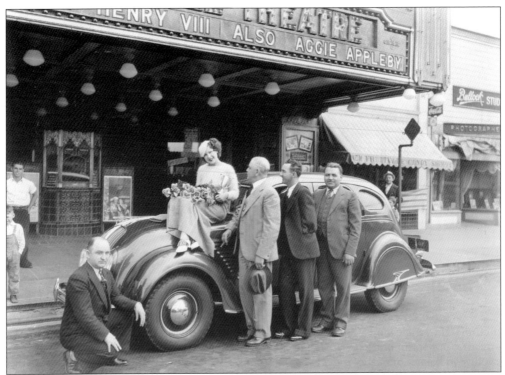

Members of the Fruitvale-Melrose Civic Club (L. M. Milton, Tony Rossi, Angelo "Pep" Tocchini, and A. D. Vallerga) and Jean Maulsby use the Fruitvale Theatre as a backdrop in November 1933 to celebrate the introduction of the new 1934 De Soto Airflow automobile, a style innovator of its time.

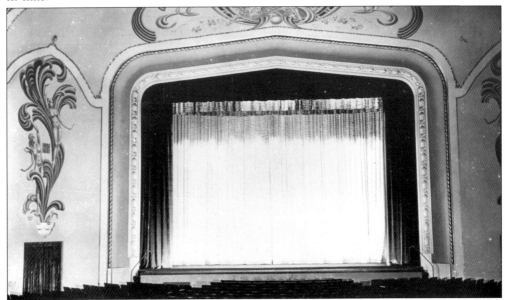

This is how the 1,224-seat New Fruitvale auditorium looked in 1942 stripped of most of its 1920s ornamentation. The pipe organ that was built in Alameda by F. W. Smith and Son has also been removed. New since the 1925 construction are the wall and ceiling murals.

Two decades after its construction, the New Fruitvale Theatre was under the direction of Golden State Theatres, which claimed to have a motion-picture house in almost every neighborhood in Oakland. The original Venetian Gothic exterior had been updated in a more modern style. A major fire closed the theatre in December 1968, but it was not torn down until picketed by irate citizens who claimed it was an eyesore.

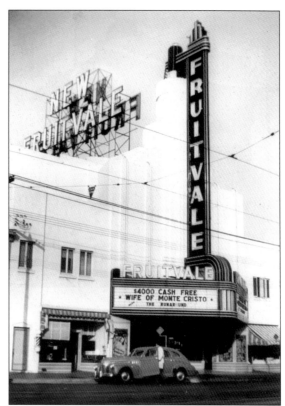

The 1915 building permit for the small 667-seat, Mission Revival theatre at 645 East Twelfth Street listed Elizabeth Loughery as owner with James F. Loughery as architect and builder. In a series of format changes, the theatre saw many names: Park, Ritz, Pix, and lastly Teatro Plaza, a venue for Spanish-language films. Cantinflas, the star of *Por Mis Pistoles*, also performed in English-language films, including *Around the World in 80 Days*. The theatre now houses a retail store.

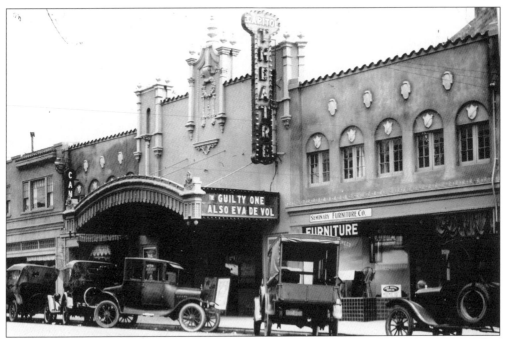

The Capitol Theatre at 5825 Foothill Boulevard was built in 1923 for Gabriel and Lenore Moulin, owners of a prestigious San Francisco photographic studio. Its architects were the Reid Brothers, who subsequently designed the Fairfax and Grand Lake. Candy counters were not yet a fixture, so patrons could stop by Capitol Sweets (at left) on the way in. In 1960, the 992-seat Capitol was resurrected as a bowling alley and later converted to a church.

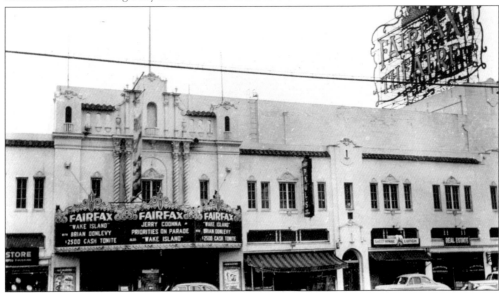

The 1,493-seat Fairfax Theatre opened in June 1926 at 5345 Foothill Boulevard under the direction of Golden State Theatres. Its Spanish Revival facade stretches 160 feet to include seven stores with apartments above. At $90,000, the official building cost was more than one-and-a-half times its neighbor, the Capitol. The film's star, Jerry Colonna (whose name is misspelled on the marquee), traveled the world as a member of Bob Hope's USO show.

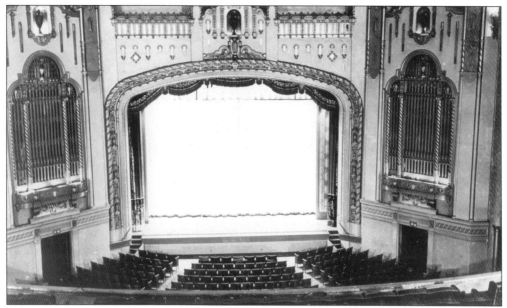

Reid Brothers gave the following description of the Fairfax interior, "The Spanish feeling prevails throughout—the main auditorium being treated as a large Spanish court, or patio, enclosed by a three-story facade . . . walls [are] pierced by many openings, with their colonnades, balconies, and niches." This 1943 view from the balcony gives a glimpse of that elaborate gilded décor with its massive organ lofts. Reid Brothers designed a nearly identical auditorium for the Golden State Theatre, which still stands in Monterey.

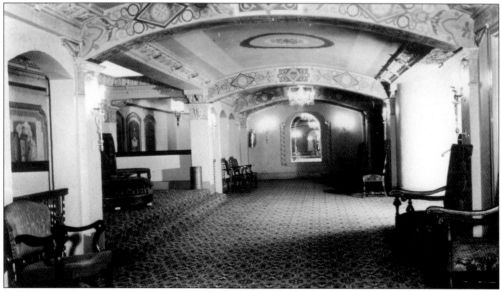

A 75- by 30-foot mezzanine foyer provided a place for patrons to wait for balcony and loge seats. The vaulted ceiling features stenciled beams. The balcony opens to the center of the mezzanine with rest rooms on either side and a room for the ushers. Traditionally the loge seats at the front of the balcony are the best in the house and worth the wait.

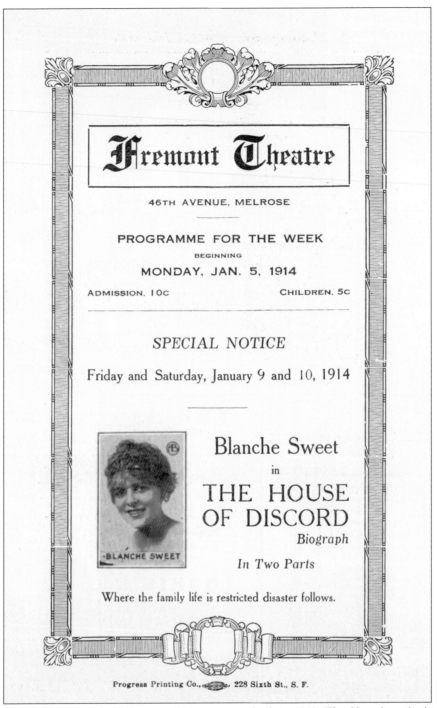

Fremont Theatre

46TH AVENUE, MELROSE

PROGRAMME FOR THE WEEK
BEGINNING
MONDAY, JAN. 5, 1914

ADMISSION, 10c CHILDREN, 5c

SPECIAL NOTICE

Friday and Saturday, January 9 and 10, 1914

Blanche Sweet
in
THE HOUSE OF DISCORD
Biograph

In Two Parts

BLANCHE SWEET

Where the family life is restricted disaster follows.

Progress Printing Co., 228 Sixth St., S. F.

The Fremont Theatre at 1666 Forty-sixth Avenue was built in 1912. The films described in this 1914 program are from such licensed distributors as Vitagraph, Pathe, Edison, Biograph, Lubin, Scenic, and Essanay. *The House of Discord* was released December 13, 1913, so the fact that the Fremont got it only three weeks later indicates it was an important venue. The theatre was converted into the Fremont Apartments in February 1925.

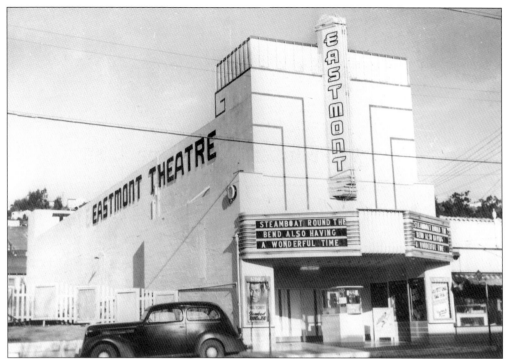

Located at 7402 Foothill Boulevard, the Eastmont Theatre was built in 1926 and, like so many others, was updated in the streamline style with the little tails of the letters on its vertical sign conveying an impression of speed and modernity. Both films are revivals from the 1930s, not unusual for a neighborhood house. By 1956, the vacant 837-seat theatre was converted to other uses—Vic Tanny's Gym and Health Club in the early 1960s and later as a church.

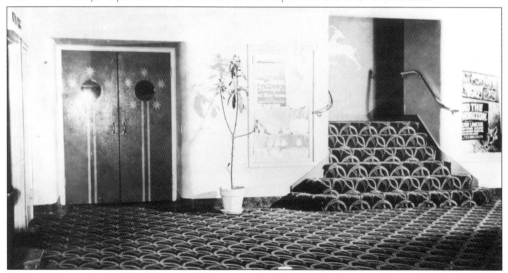

The Eastmont Theatre's display case in the center of this 1942 photograph promotes free dinnerware given out to the ladies every Wednesday and Thursday, a business builder left over from the Depression days of the previous decade. Note that there is no snack bar, as it was a concept that had not yet arrived. The interior design expresses movement with circles and swirls in the carpet, rounded corners, porthole windows, and curved stair rails.

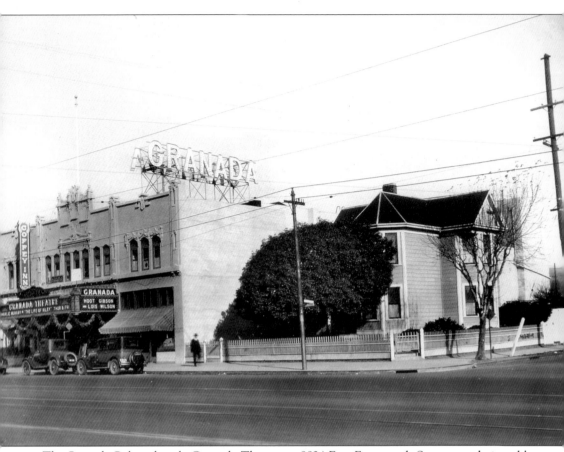

The Spanish Colonial–style Granada Theatre at 8824 East Fourteenth Street was designed by Albert W. Cornelius, the man also responsible for Berkeley's T&D (renamed the California) and Strand (later known as the Elmwood). The building itself (not the theatre) is named for the Toffelmier family, pioneer business leaders in the Elmhurst district. John Peters managed the Granada under the umbrella of the Golden State organization. Note the roof sign that could be seen for blocks.

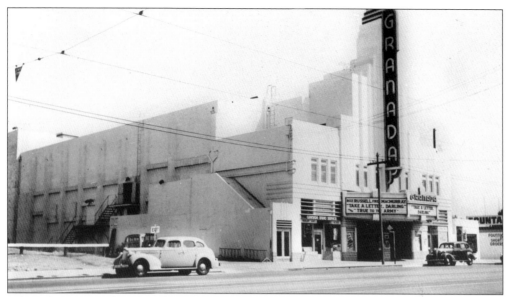

After a fire in 1939, thought to be caused by a cigarette stubbed out in the loge carpet, the Granada was extensively renovated and updated as seen in this 1942 photograph. Mark T. Jorgensen, who had designed the Parkway, was architect for the "swank" and "streamlined" design. The roof was extended upward and a central tower and vertical sign were added. Although the building has now been converted to retail use, it retains the V-shaped marquee from this era and a vertical sign.

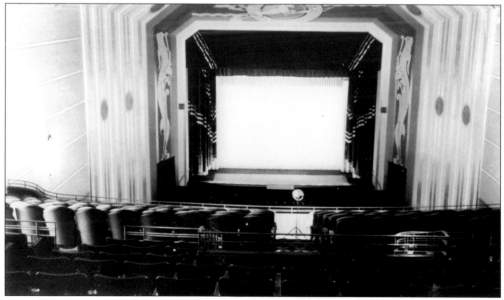

The 1,495-seat interior of the Granada is viewed from the balcony in this 1942 photograph. The post-fire renovations included an enlarged balcony and screen. A mural of a flying horse decorates the proscenium. Today the theatre is a food store, a drop ceiling hides that mural, the balcony is gone, and shoplifters are spotted by an employee perched behind the projector window.

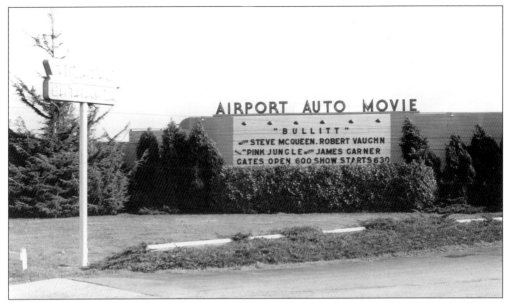

The Airport Auto Movie (later Movies) at 132 Ninety-eighth Avenue was built in 1949 for Sal Enea, a member of a family of longtime theatre entrepreneurs who had several theatres and drive-ins, including the Enean Concord (now used as a church) and the Enean Pittsburg (currently in redevelopment). The Oakland drive-in was demolished in 1971.

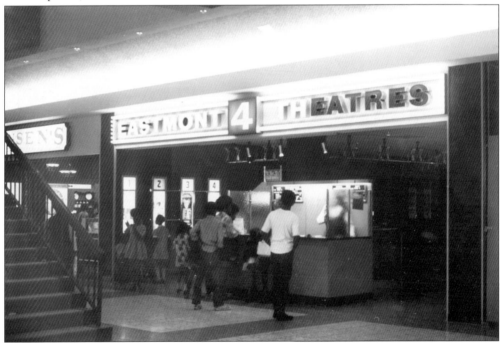

In 1970, American Multi Cinema, Incorporated (AMC) constructed the Eastmont Four cinema in the shopping center of the same name at Foothill Boulevard and Seventy-third Avenue. Like the mall itself, the Eastmont Four was not a financial success and closed after a few years of operation. Today the struggling mall has been remade as a town center with community-service organizations, including a library, health center, and police substation as its major tenants.

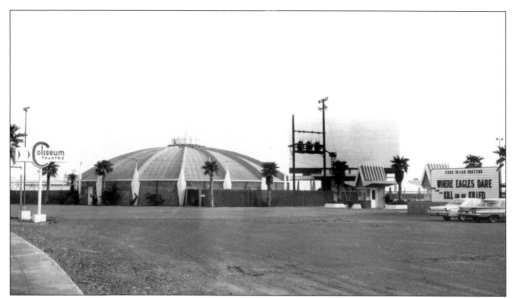

The Coliseum Drive-In is a familiar site to travelers on Highway 880. The entrance is at 5401 Coliseum Way (formerly Industrial Drive). This photograph was taken in the summer of 1969 when the theatre was about three years old. The drive-in eventually added three more screens but closed as a theatre in December 1994. In recent years, it has hosted a flea market. One screen and the dome-shaped concession building are still standing.

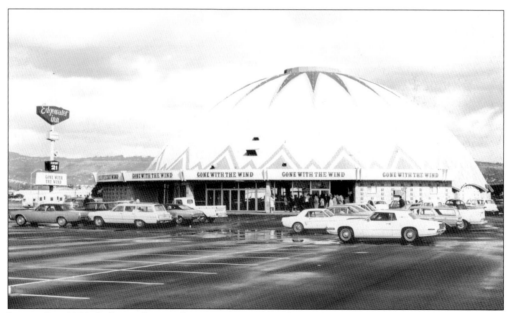

Located at 8201 Oakport Street, Century 21, an upscale single-screen operation, opened in 1968 with a 70-mm revival of Gone with the Wind. Exclusive first runs of big films such as Hello Dolly and The Andromeda Strain attracted sizeable audiences but more commonplace titles that could be seen elsewhere in more convenient locations did not. The auditorium was subdivided into an eight-screen multiplex in the mid-1970s and closed permanently on March 29, 2000. Hegenberger Gateway Center is now at the site.

The name in tile reminds one that patrons once stepped across the threshold to the Home Theatre at 1434 Thirteenth Avenue. On Wednesday evenings in its heyday, the Home awarded someone a "handsome gold watch or a silver dinner set." The little Mission Revival theatre, built in 1912 and in business until the Depression, was long ago remodeled as a store and apartment building. Gone also are other little theatres: Brown's, Fremont, Globe, Edison, Oakes, Ark, 23rd Avenue, Bell, and on East Fourteenth Street, Fisher's, Gem, F. M. Wade's Star Nickelodeon, Melrose, Elm, Alpha, Union, Bijou, Grand, and John's. Building records and newspaper stories about these theatres survive, but photographs of them in operation are elusive. The few that remain are now apartment buildings, restaurants, stores, or churches. They were small, but they were an important chapter in the evolution of motion-picture exhibition.

Five

THE PARAMOUNT GREETS YOU

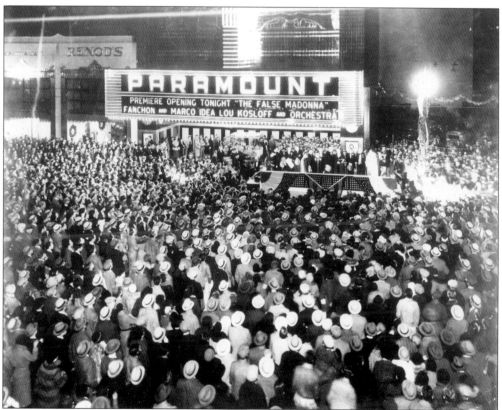

On December 16, 1931, thousands of Oaklanders turned out to witness the opening of what was to be Oakland's greatest, grandest, and largest art deco movie palace at 2025 Broadway. It had been conceived five years earlier by Publix, Paramount's exhibition division, whose depressed financial condition led to its being passed over to Fox West Coast before construction was completed. The theatre was the first in Oakland to be specially built for sound and was its last large-scale, single-screen theatre. The opening-night program began with personal appearances by Gov. "Sunny" Jim Rolph, radio's Hugh Barrett Dobbs, and Hollywood stars such as George Bancroft, Elissa Landi, John Boles, Frances Dee, and San Francisco–born actor John Breeden, who was featured in the opening-night film, *The False Madonna*. A newsreel and cartoon, orchestral selections, and a stage show by Fanchon & Marco with the Sunkist ensemble completed the program.

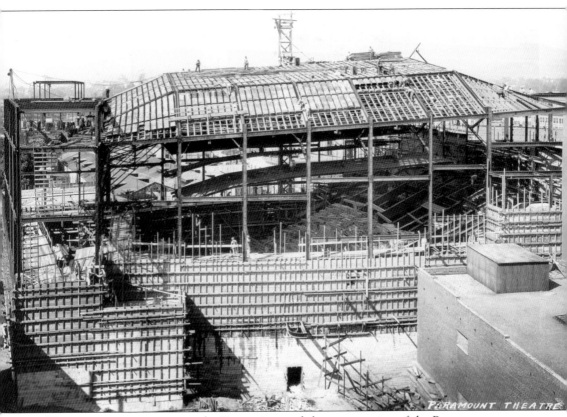

The nation was one year into the Depression, and the construction of the Paramount was seen as a boost to the local economy. Officials of 10 East Bay cities and two counties attended the groundbreaking for the yearlong project that would involve dozens of subcontracts and employ hundreds of artisans, steelworkers, plumbers, carpenters, and builders. In this view, Broadway is on the right, with the stage house at left. In order to preserve sight lines, the massive steel skeleton incorporates a single steel girder, weighing 105 tons, from which the balcony is suspended. The 130-foot-wide and 150-foot-long auditorium would be outfitted with 3,434 seats and a 66-foot-wide proscenium. Although impressive in size, the stage was smaller than the 75-foot revolving stages in Harry W. Bishop's Oakland playhouses. The rear of the auditorium is built at odd angles to fit on the irregularly shaped lot. The official building permit gave the construction cost as $787,144; press accounts inflated that figure to $3 million or more. The actual cost of the structure probably fell between those figures.

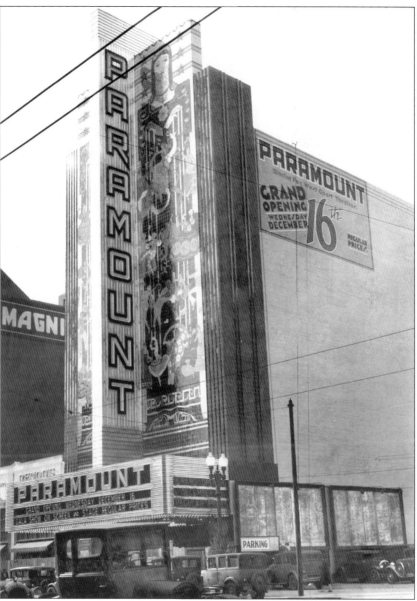

Timothy L. Pflueger, of the firm Miller and Pflueger, received the Paramount commission for the palatial art deco theatre. Theodore Bernardi directed the artistic program. Pflueger was at the apex of a career that included the Castro, El Rey, and Alhambra in San Francisco as well as 450 Sutter and the Pacific Telephone and Telegraph building also in the city and the Alameda Theatre in Alameda. The Paramount was the most ambitious of Pflueger's theatre designs and was the largest theatre built in Oakland. The neon vertical rises 10 stories, and unlike many large theatres, the facade is not interrupted by offices at its base. Mural art flourished during the Depression, and the Paramount's tiled mosaic brings that art to the street for the public to enjoy. The mural depicts male and female puppet masters dangling performers and is said to be the product of collaboration between Pflueger and artist Gerald Fitzgeraldwith contributions from others. It was executed in shades of vermillion, yellow, sunset tans, blues, and turquoise, with gold trim in terra cotta tile manufactured by the Gladding, McBean, and Company.

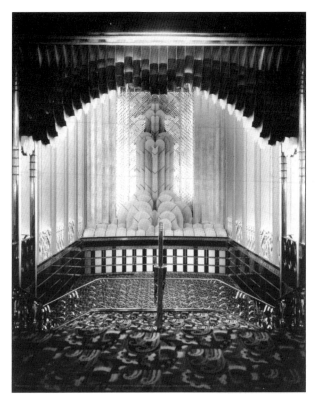

In the six-story grand lobby looking toward the Broadway entrance is the "fountain of light," executed in layers of etched-glass panels indirectly illuminated by amber lightbulbs. Designed by Gerald Fitzgerald, who studied architecture at the University of California at Berkeley, the luminous fountain is set against a background of grillwork made of 12-inch-thick strips of galvanized metal lit by green lights, giving the effect of dense tropical foliage.

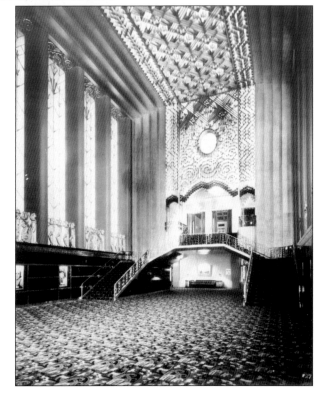

In this view looking into the theatre, art glass panels illuminated from behind form the side walls of the grand lobby. It is easy to forget that on the other side, exterior walls are unadorned, painted concrete. Inside the polished black marble used at the base of the concrete piers is adorned by a line of gold silhouettes of stylized females. The metal grille continues from behind the fountain of light across the ceiling, dropping like a curtain above the grand staircase.

116

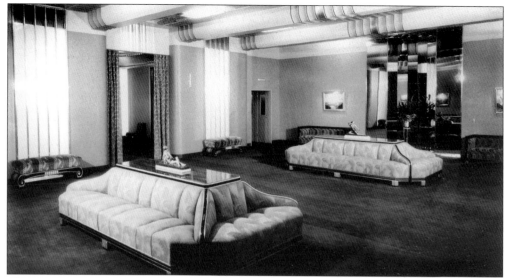

The sitting room outside the women's lavatory is part of a suite of lounges that also includes a smoking room. Throughout the theatre, indirect lighting is employed; in this case, glass panels lit in amber span the ceiling, while mirrors and glass tabletops reflect the illumination. Lounge suites for men and women are on both the balcony and lower floors.

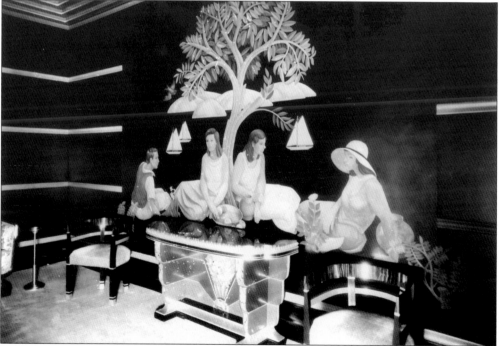

Charles Stafford Duncan, trained at the Mark Hopkins Institute (now California Institute of Fine Arts), was commissioned to design the mural in the lower level women's smoking room. However, during restoration, it was observed that smoking had left a coating in every room of the theatre. Duncan painted a man and three women against a black lacquered background that had been suggested by Pflueger, another indication of how Pflueger's influence is everywhere in the building.

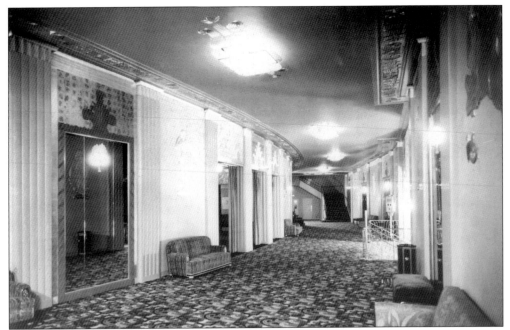

The mezzanine-level foyer serves the lower balcony. The light fixtures are pattern-etched glass panels, and gilded bas-relief borders the ceiling. The foyer mirrors the curve of the balcony seating. The stairs at right lead down to the landing above the grand lobby. The carpeting has representations of leaves, flowers, and pods in shades of yellow, green, and browns from nature.

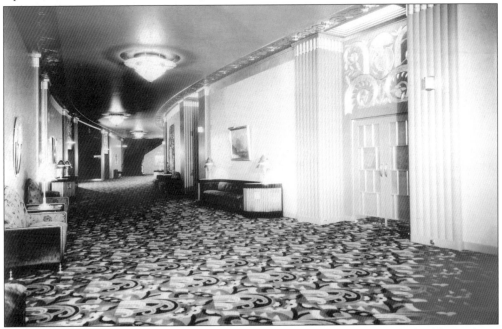

This is the orchestra-level foyer, looking from the Twenty-first Street side of the building. Above the auditorium doors, bas-relief panels depicting parrots are finished in gold as elsewhere in the building. In the renovated Paramount, the Twenty-first Street entrance now houses the main ticket office, so theatregoers often enter through the enlarged vestibule that leads to this area.

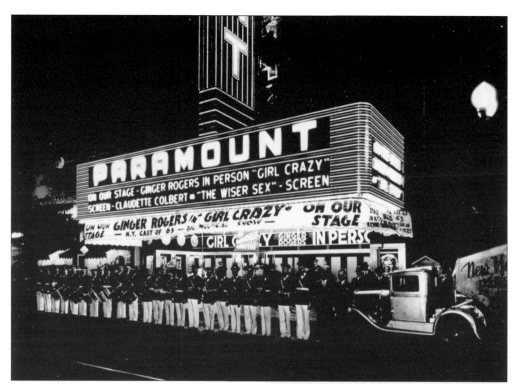

The April 1932 presentation of *Girl Crazy* was an experiment in which Ginger Rogers and some of the players who had appeared in the New York stage production presented a cut-down version on the Paramount stage. Although well received, the presentation stumbled because nuanced dialogue did not work in the vast auditorium. The movie, *The Wiser Sex*, is a "pre-code" 1932 gem that survives as a single original nitrate print at the UCLA Film and Television Archive. Three months after Ginger Rogers appeared, the Paramount closed, unable to sustain the expense of constantly changing stage shows and costly celebrity-studded promotions. When the Paramount reopened in June 1933, the focus shifted to motion pictures, with periodic stage entertainment such as bandleader Ted Lewis and his orchestra appearing on stage in late 1935 (right). The vertical, with its one mile of tubing, is an integral part of the building's design. It was created at the Electrical Products Corporation plant in West Oakland, which put 6,000 hours into the sign developing an improved illumination tube known as Zeon in order to avoid use of the patented neon design.

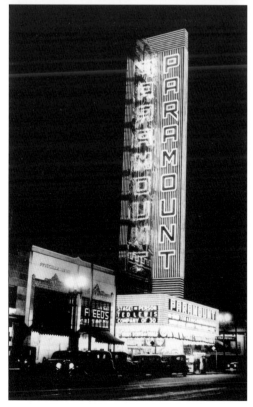

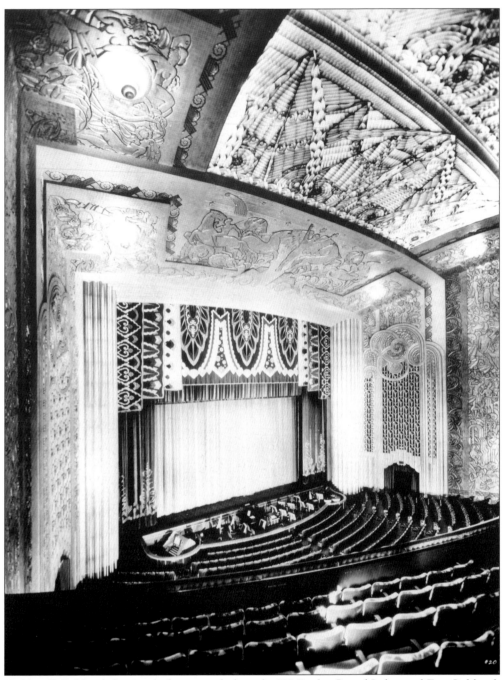

Unlike all Oakland theatres before it, including the T&D, the Grand Lake, and Fox Oakland, the Paramount was specially built for sound films. Timothy Pflueger paid special attention to acoustics by adding textured side walls and perforated fabric on the rear walls. It was said that the slightest whisper from the screen was audible. Inside the control room was a sign that warned, "Quiet. You can be heard throughout the auditorium." The sculpted plaster relief panel above the proscenium, by Ralph Stackpole working with Robert Howard, depicts Poseidon, ruler of the waves and sea, flanked by horses.

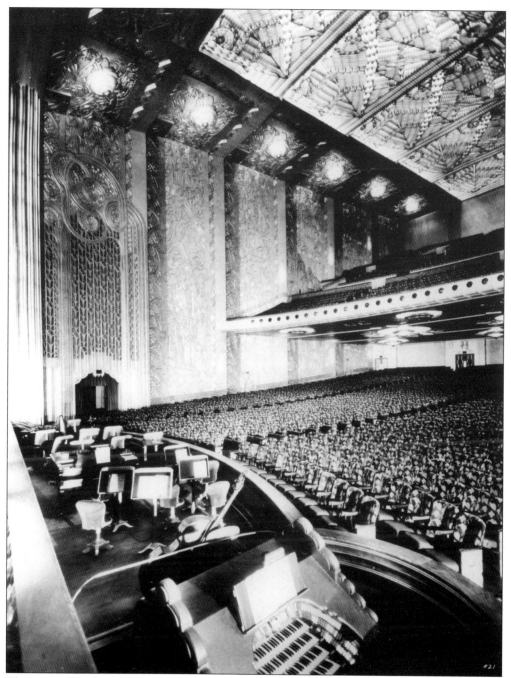

The original Publix I (Opus 2164) organ was designed by WurliTzer expressly for the Paramount. The organ console was confined on the left side of the orchestra pit. Grillwork above the exits concealed the pipes and percussion instruments. The organ was sold during the late 1950s and was eventually installed in an Indiana restaurant. Edward Millington Stout III restored the replacement organ played in the theatre since 1981.

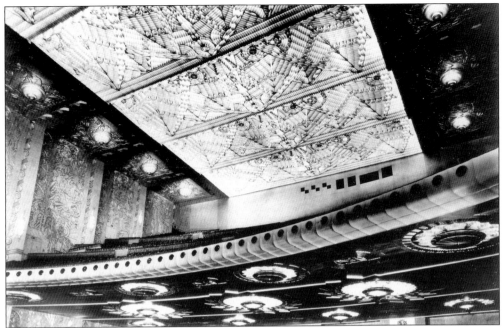

Robert Boardman Howard, who had previously worked with Pflueger on sculpture and murals for the San Francisco stock exchange, executed the incised decorative relief (called graffito work by Pflueger) for the auditorium walls and ceiling from ideas by Gerald Fitzgerald. The mold-making technique was reportedly adapted from a technique used for making military relief maps. The *Oakland Tribune* observed that decorative relief replaced the customary theatre murals, and in addition to adding beauty, they diffused sound waves.

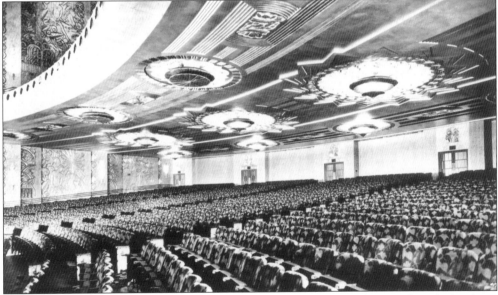

Rear orchestra seating below the balcony soffits is lighted by 11 large fixtures described as lotus flowers or celestial bodies. They are constructed with the same type of metal strips seen elsewhere in the theatre. Some of the fixtures also serve as vents for the air-conditioning system. The mohair seat backs are upholstered in a green and gold floral design continuing the natural theme.

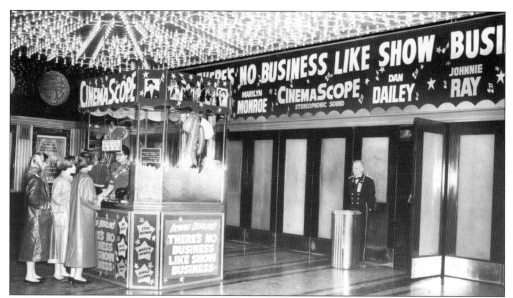

It is New Year's Eve, 1954, and cashier Esther Kelly, who opened the Fox Oakland a quarter of a century earlier, is still at the switch, knocking out tickets to happy customers of the still-prosperous Paramount, where CinemaScope had premiered a year earlier. Since the 1973 restoration, patrons are served by a larger box office on the Twenty-first Street side of the theatre, directly opposite the parking garage.

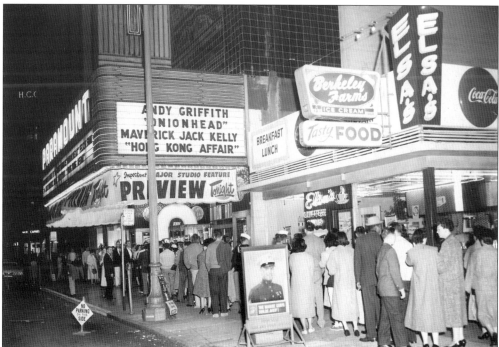

In the fall of 1958, with the names of Andy Griffith and television favorite Jack Kelly on the marquee, plus a sneak preview, guarantee the Paramount long lines and another full house. *Onionhead* also marked the feature-film debut of localite Paul Mantee, who carved out a successful career in motion pictures and television as well as authoring a book or two along the way.

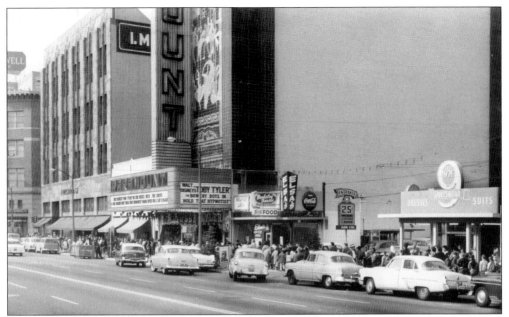

The Walt Disney name on the marquee was all that was necessary to bring an army of parents downtown with their kids. Block-long lines in two directions answer the call in January 1960 as the Paramount unreels *Toby Tyler* with the Bowery Boys in *Hold That Hypnotist* thrown in for good measure. The rectangular marquee pictured here would be replaced in the 1960s by the angled version pictured on the next page.

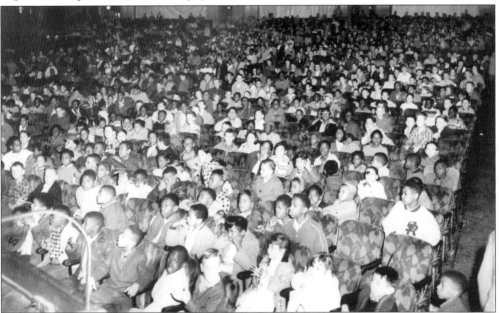

It is 10:15 a.m. on a Saturday in February 1959, and a packed house awaits appearances on the Paramount stage by Chief Red Feather and Princess Faun in a presentation called *Miracle Arrows of the Red Man*. The featured film was a recent Walt Disney release, *Tonka*, starring Sal Mineo, plus a second feature, *The Mark of Zorro*, made in 1940 starring Tyrone Power, that was making the rounds again.

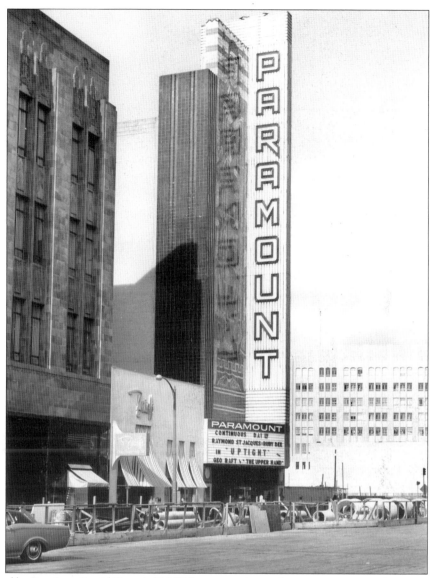

Besieged by Bay Area Rapid Transit (BART) construction and an ever-increasing downtown crime rate, the Paramount puts up a brave front, but business is hurting badly. To make matters worse, Walt Disney films, up until recently a sure cure for the blues, are now being premiered at the more inviting Grand Lake; important new first-run films are now bypassing downtown altogether, opening up in the neighborhoods at such venues as the Piedmont, Parkway, Ciné 7, and even the Fairfax and Fruitvale Theatres, leaving the big downtown theatres with meager pickings to fill all those empty seats. By the late 1960s, the Paramount, attempting a quantum leap from Walt Disney films such as *Babes in Toyland* to black exploitation flicks like *Up Tight*, only succeeded in pounding more nails into its own coffin. Its last mainstream movie was shown in September 1970; after that, the theatre was used for privately sponsored matinees. The Oakland East Bay Symphony, which had been seeking to move from the Oakland Auditorium, purchased the theatre in October 1972 and began a comprehensive restoration program. When the Paramount reopened in 1973, the BART system that had been a liability during construction was now up and running and proved to be an advantage, with the station only 93 steps from the theatre.

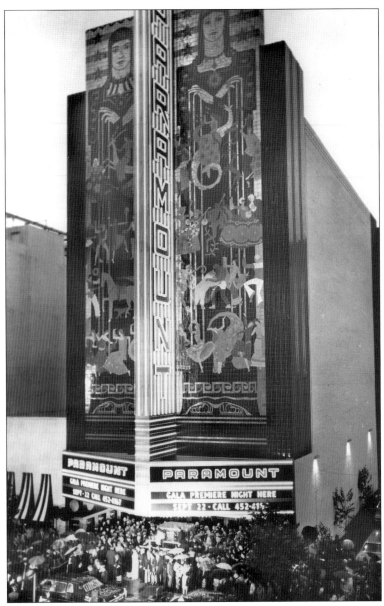

Saved from the wrecker's ball, the restored and reborn Paramount reopened on September 22, 1973. Every effort was made to preserve the original artistry of the theatre. The frame of the 1960s marquee was retained in the restoration effort, but its readerboards were replaced with ones patterned after the originals, and the display letters were created in a plastic laminate designed to look like the 1930s–era milk glass letters. Inside carpets and upholstery were rewoven to match the originals, the walls and fixtures were cleaned and freshly decorated following the original scheme, and the infrastructure was updated to meet current needs. Approximately 65 percent of the Paramount's original furniture was available for reconditioning. The fabulous Paramount most deservedly has been declared a national, state of California, and city of Oakland historic landmark. The theatre now hosts a regular season of symphony concerts, musical and stage shows, and a revival film program that includes vintage newsreels and cartoons. Before the movie, patrons are serenaded by a concert on the WurliTzer organ. Today, as in 1931, the Paramount greets you.

INDEX

ACROSS AMERICA, PEOPLE ARE DISCOVERING SOMETHING WONDERFUL. *THEIR HERITAGE.*

Arcadia Publishing is the leading local history publisher in the United States. With more than 3,000 titles in print and hundreds of new titles released every year, Arcadia has extensive specialized experience chronicling the history of communities and celebrating America's hidden stories, bringing to life the people, places, and events from the past. To discover the history of other communities across the nation, please visit:

www.arcadiapublishing.com

Customized search tools allow you to find regional history books about the town where you grew up, the cities where your friends and family live, the town where your parents met, or even that retirement spot you've been dreaming about.